# Draw
*yourself*
# Calm

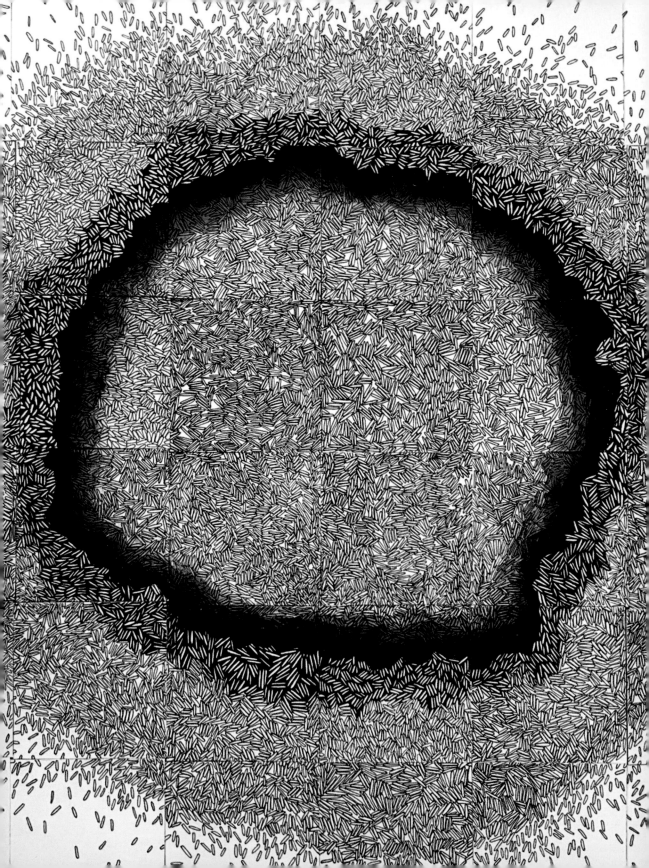

# Draw
*yourself*
# Calm

*draw slow,
stress less*

**Amy Maricle**

**NORTH
LIGHT
BOOKS**

**NORTH LIGHT BOOKS**

An imprint of Penguin Random House LLC
penguinrandomhouse.com

Printed in China

10 9 8 7 6 5

ISBN: 978-0-593-54101-2

Conceived, edited, and designed by
Quarto Publishing
an imprint of The Quarto Group
The Old Brewery
6 Blundell Street
London N7 9BH
www.quarto.com

QUAR.343035

Copy editor: Caroline West
Projects editor: Anna Galkina
Photographer & Illustrator: Amy Maricle
Photographs on page 144: Brittany Adams
Deputy art director: Martina Calvio
Art director: Gemma Wilson
Senior commissioning editor: Eszter Karpati
Publisher: Lorraine Dickey

**FSC**
www.fsc.org

**MIX**
Paper | Supporting
responsible forestry
**FSC® C016973**

# Contents

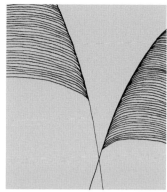

Slowing Down and Tuning In
Through the Senses: Fan Pattern **30**

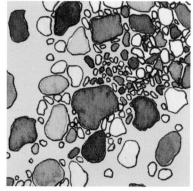

Asking "What If...?"
Cobble Pattern **34**

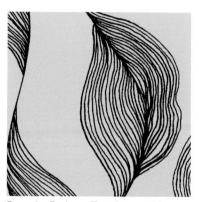

Be an Art Explorer: Twist Pattern **38**

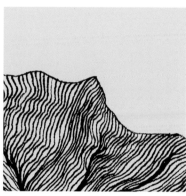

Where is Your Edge? Edge Pattern **42**

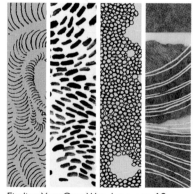

Finding Your Own Way: Innovate **46**

Don't Make Art: Chicken
Scratch Pattern **50**

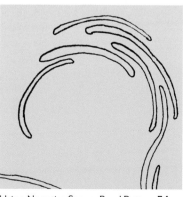

Using Negative Space: Bend Pattern **54**

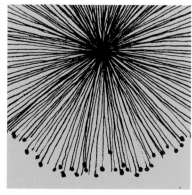

Locating Your Breath: Exhale Pattern **58**

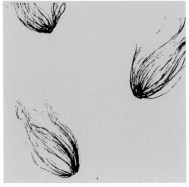
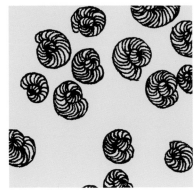
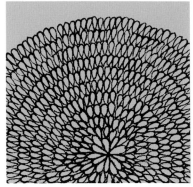
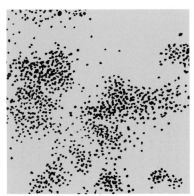
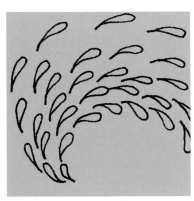
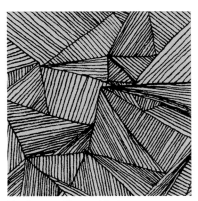
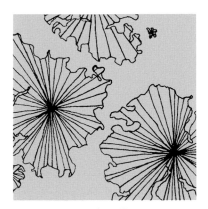
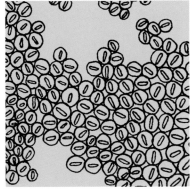
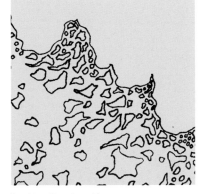

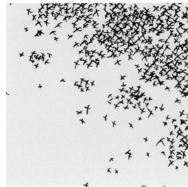
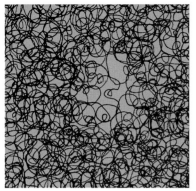
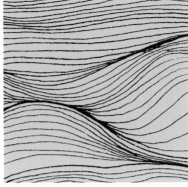
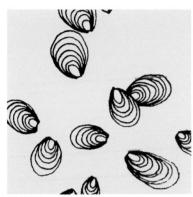
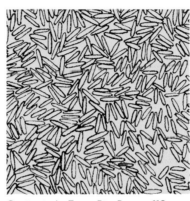
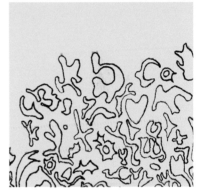
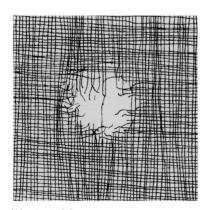

# Meet Amy

Walking in and exploring the woods as a child was always magical for me: gurgling creeks that spoke of faraway lands, tree vines that swung me through the air, and soft carpets of moss to lay down on and look up at the sky. I made up my own songs in the fields and my own forts and games in the trees. In nature, I felt creative, powerful and grounded.

I remember standing alone in the snow at night, on the top of the hill where we lived, with my breath emerging in silent clouds. The twinkle of each snowflake reflected the full moon lighting up the sky. I was awestruck. I felt so big and yet incredibly tiny all at once. My place was in nature. While things inside my house were not always peaceful, outside I felt grounded and alive.

As I got older, I learned to connect nature and art more deeply and bring these two sources of joy together to create art with and from nature. For the last few years, I've been exploring nature's patterns. The patterns in this book are the result of my observations in the woods, by the ocean and in the desert, as well as my own mark-making explorations. My criteria for each pattern is that it should be simple enough that anyone could draw it, but complex enough to make room for something delightful.

That's what fascinates me about these patterns—I could continue to make little changes, digging deeper and deeper into my imagination, and come up with something fresh each time. This is what I hope you do with slow drawing. You can start by copying my sample, but I hope each pattern leads you on a journey into rich creative territory that is all your own, both outside and on the page.

I can't wait to start this journey with you.

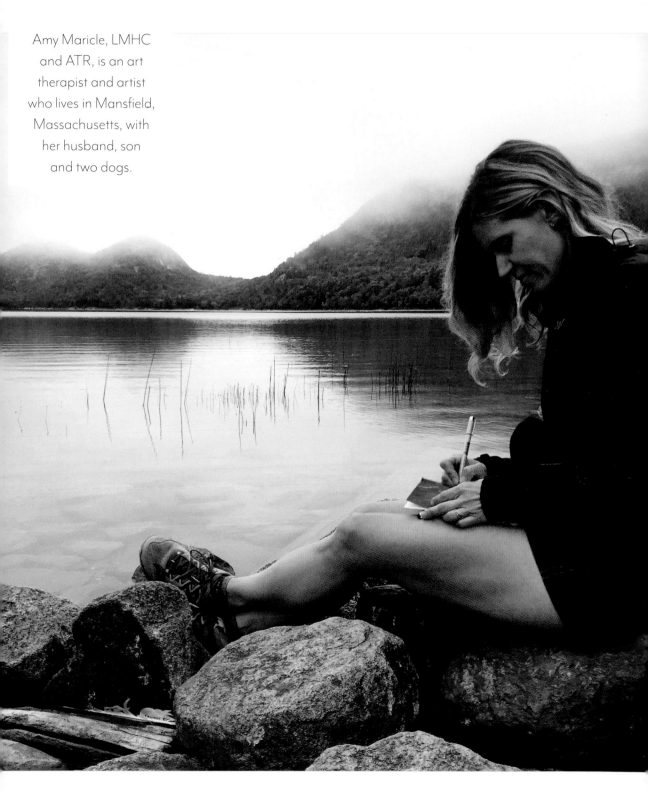

Amy Maricle, LMHC and ATR, is an art therapist and artist who lives in Mansfield, Massachusetts, with her husband, son and two dogs.

# Introduction

Let's start by talking about what slow drawing is, review the tools and materials you need to get started, and look at some easy ways to integrate slow drawing into your life.

# What is Slow Drawing?

Slow drawing is a mindful art practice. Mindfulness simply means paying attention to what you are doing and experiencing in the moment. I find the easiest way to do that is to notice through my senses. So slow drawing is drawing slowly enough that you notice what it's like to draw—through all your senses.

I do some meditation practice, but always find that it does not feel completely natural to me. I'm by no means the most relaxed or mindful person; I have perfectionistic tendencies and I sometimes have a short fuse—in other words, I'm imperfect and human, just like you. And just like you, I need ways to slow down. Meditation is good, but it never feels as energizing, adventurous and fun as meditating through art. When I'm drawing, painting and working with my hands, I find that my thoughts slow down, my breathing settles into a slower, deeper rhythm, and I feel more grounded. I realized that slow art was a mindfulness meditation for me—a way to have a singular focus on what I was doing in the moment—just as in meditation when you focus on the breath.

In my previous work as an art therapist, and now teaching, I find that movement-based work is incredibly effective because it puts people in charge of their body and asks them to focus on that action. It's much easier to focus on the movement of a paintbrush, and the feel of it in your hand, and the colors that appear on the page than to wrangle an overstressed mind into focusing on each inhale and exhale. Making art is an active way to ground anxious bodies and overactive minds.

Why Slow Draw?

People enjoy slow drawing for different reasons. Some want a creative way to ground themselves and feel calm, while others are artists who wish to overcome creative blocks or infuse more meaning into their art. I slow draw for all those reasons. It's fun and relaxing, and going slow helps me tune in to the creative ideas that bubble up from my imagination. Slow drawing has helped me to practice mindfulness while I'm creating, but also in the rest of my day. I now find that I tune in to the pattern of the bubbles in boiling pasta water, the sound my feet make as I'm running, and the texture of fingers when I fold my hands. Slow drawing helps draw us into the moment.

We are in a period of endemic overstimulation and rapid-fire information. It's no surprise that there's a movement toward slow everything right now. Our brains and bodies face a constant barrage of news, images and sounds via the screens we carry in our pockets. Our need for rest, pause and slowness is real. That's why I enjoy this journey so much. Let's practice together and do our best, imperfectly.

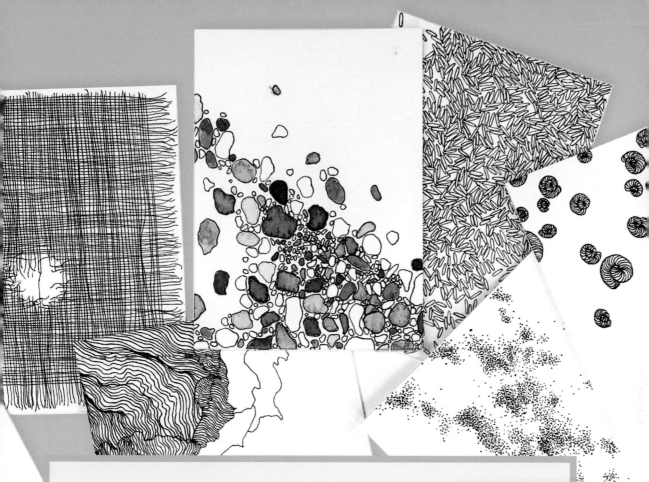

As you draw the nature-based patterns in the book, practise noticing in the following ways:

> **Feel:** What does the pen feel like in your hand? Is it cool or warm, hard or soft? Smooth or rough? Can you feel the miniature hills and valleys in the watercolour paper as you draw? Is there a feeling of comfort or tightness in your grip?
> **See:** What colours and shapes do you notice appearing before you? What do these remind you of? What if you looked at the lines appearing with curiosity instead of judgement?
> **Hear:** Can you hear a sound from the pen or paintbrush on the paper? Is it a scratching or a nearly silent gliding? What is the sound of your arm moving on the table? Can you hear your breath? Other outside noises?
> **Smell:** What is the smell of the materials you are using? Can you smell your coffee or tea?
> **Taste:** Can you taste your beverage of choice or perhaps a little something you're nibbling on? Be careful not to taste one thing – your paint water!
> **Notice your thoughts:** 'Random' song lyrics, sudden memories and other musings of the imagination bubble to the surface. Let your art channel them if you wish.

# Tools and Materials

To begin slow drawing, you don't need any special materials at all—just a pen and paper. However, as with many things, having the "right" supplies can increase your sense of success and pleasure as the tools respond as they are supposed to. Here are some of the reasons I think getting a few quality supplies pays off:

• A waterproof drawing pen won't smudge when you touch it with your hand or add watercolor.

• Good watercolor paper will curl much less than cheaper types of paper, which may become too wrinkled to draw or paint on.

• Watercolor paints (ideally, better student grade or artist's grade) will bloom and move in beautiful ways on the paper, while cheaper paints will not. Low-grade watercolor paints are not richly pigmented and will fade easily.

## TIP

A good drawing pen and a student-grade pad of watercolor paper costs just over $10. You're worth a $10 investment to set yourself up for success. Adding a medium-grade travel watercolor set means you will still come to under $30. Start small, and see if the practice is for you. You can always expand later. I am a big fan of having a few good-quality supplies, rather than cluttering up your art space with many choices of poor-quality materials. A cluttered space makes it hard to find supplies and get started. This can fuel the inner critic's list of excuses and criticisms meant to keep you from creating.

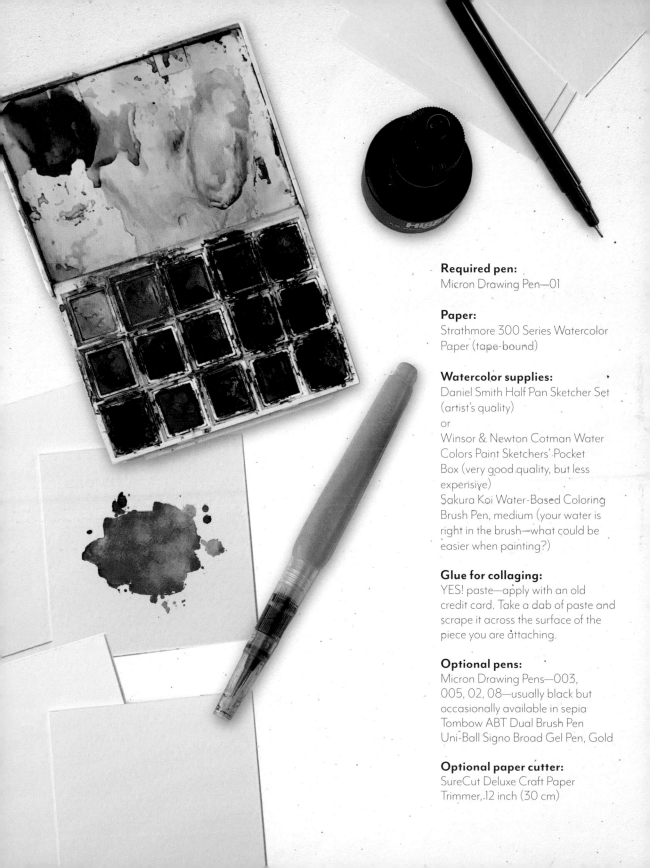

**Required pen:**
Micron Drawing Pen—01

**Paper:**
Strathmore 300 Series Watercolor
Paper (tape-bound)

**Watercolor supplies:**
Daniel Smith Half Pan Sketcher Set
(artist's quality)
or
Winsor & Newton Cotman Water
Colors Paint Sketchers' Pocket
Box (very good quality, but less
expensive)
Sakura Koi Water-Based Coloring
Brush Pen, medium (your water is
right in the brush—what could be
easier when painting?)

**Glue for collaging:**
YES! paste—apply with an old
credit card. Take a dab of paste and
scrape it across the surface of the
piece you are attaching.

**Optional pens:**
Micron Drawing Pens—003,
005, 02, 08—usually black but
occasionally available in sepia
Tombow ABT Dual Brush Pen
Uni-Ball Signo Broad Gel Pen, Gold

**Optional paper cutter:**
SureCut Deluxe Craft Paper
Trimmer, 12 inch (30 cm)

# Weaving Slow Drawing into Your Day

Whenever we try to add something new to our lives, it's natural to immediately think we don't have time. The truth is, though, unless you're holding down two jobs and caring for your kids and aging parents, you probably do have time, especially for small art.

- Small art feels loose, adventurous and fun. I can work for 15 minutes and make a significant impact on a small art piece—and on my mood.
- As an artist, working small allows me to experiment more. I have the time and energy to explore variations for each idea, helping me to dig deeper into my imagination and cultivate my best work.
- Using small bits of paper feels less "wasteful," a common complaint that the inner critic uses to stop us exploring our creativity.

You have time for the things you want to have time for. Some of these things we choose thoughtfully, like spending time with family and friends, and others we allow to just happen, like scrolling through social media and checking email.

When we look at our phone use, it shows how much time we waste. Most of us stare at a little rectangular screen for hours each day. It's a mindless habit. I have this bad habit too, but I try to create opportunities for myself to make art in the moments in between, rather than mindlessly looking at my phone.

Let your slow drawing practice be an opportunity to reflect on what you really want in life. If you want more creativity and relaxation in your day, you can make it happen. You deserve to relax and let go. Give yourself permission to do this through art. Here are some tools to help you weave sessions of slow drawing into your day.

## Create in the in-between moments:

- While waiting at the doctor's office.
- While in the car (parked, of course) waiting to pick up kids from activities.
- While the water is boiling for dinner.
- Anytime you pick up your phone (yup, many of these times you could be drawing instead).

## Connect Slow Drawing Time to an Existing Habit:

- Draw when you first wake up or before you go to sleep.
- Draw just after you eat breakfast, lunch or dinner.
- Draw when you need a break from work (keep a small portable art kit on your desk or leave a few cards or pieces of paper out that are still in progress).
- Draw while you watch a movie or TV. This is obviously less mindful than quiet, focused time, but still fun and helpful.
- Schedule art time into your calendar.
- Make an art date, either with yourself or a friend.
- Draw any time you pick up your phone— you could be drawing instead of scrolling mindlessly!

**I think it's helpful to keep your approach playful. Experiment with many of these ideas and see what feels good to you.**

## Pre-Prep Your Materials

Part of the key to weaving creativity into your life is prepping materials, so that when you have a moment to create or feel inspired, you can pick up your pen and draw right away without the obstacle of preparation to waste your time or sidetrack you. When I have lots of pre-cut watercolor cards, I dive right into drawing and painting. It also helps me feel I have more room to take risks and experiment. Each little paper feels less "precious." Creative preparation is also a great activity for those moments when you wish you felt creative, but don't. It's a way of stirring the pot, and gets you ready for the next creative session. For slow drawing, cut up lots of watercolor cards. In this book, all my cards are 3½ x 2½ inches (9 x 6 cm) or 3 x 3 inches (7.5 x 7.5 cm), but you can use a variety of small sizes.

## Carry a Portable Art Kit

I highly recommend always carrying a stack of your pre-cut cards, a drawing pen, and your watercolors and water brush. If you keep the kit light and easily accessible, you won't mind carrying it. This makes it easy to incorporate your drawing practice into those "in-between" moments. You can keep a couple of small portable art kits for slow drawing. I keep the watercolor one on my desk and another in my purse. Other ideas include: in the glovebox, next to the TV or computer, or in your lunch bag for work. Anywhere that facilitates you slow drawing is a good idea.

# Slow drawing warm-ups

Let's dive into slow drawing. In this section, you'll find an intention-setting visualization exercise, a few different ways to relax and let go of the idea of "perfection" while making art, and fun ways to look for inspiration in the natural world around you.

# Intention-Setting Visualization

This exercise is a wonderful way to open your drawing practice. By slowing down and tuning in to your body, you set the stage for drawing mindfully. Many of my students enjoy the visualization almost as much as the drawing, as it helps them to settle into a slow rhythm before they even pick up their pen.

   Read through the visualization script below to familiarize yourself with it. You may want to memorize the gist of it and talk yourself through it mentally each time, or you can record it on your phone, so you have a guided visualization. If you record it for yourself, be sure to read the script slowly, pausing between prompts, to give yourself time with each cue. You may take anywhere between three and 15 minutes for this exercise. If you feel nervous about time, set a timer before you begin, so that you can relax more fully.

   As with all the suggestions I offer in this book, please listen to your own body and modify the practice, so it feels as comfortable and nourishing as possible.

**1** Sit in a comfortable seat, with your feet flat on the floor and hands resting on your lap or the table.

**2** Allow your eyes to close gently or focus softly on the floor or table in front of you.

**3** Make any little adjustments you need in your body in order to find a bit more comfort in this moment. You can do this at any time during the visualization.

**4** Begin to notice the natural rhythm of your breath. Without trying to change or judge it, follow each inhale and exhale with your attention. Know that your breath is just right in this moment.

**5** You can try to sigh as a way to settle into your breath. Focus your attention on the sound of the air moving in and out.

**6** Notice what it feels like as the breath moves into the body, expanding the chest and belly, and then what it feels like as it moves back out, the chest and belly falling once more.

**7** Gently follow the wave of your breath moving in and out of your body. Remember that there's no right or wrong—your only job right now is noticing gently.

**8** You might play with different ways to tune in to your breath. Can you feel the air passing through your nose? Can you feel it expanding your ribs? What part of your body moves the most as you breathe? And the least?

**9** At this point, when you feel like you have found some relative quiet in your body, I invite you to visualize that you can clear a space in the very core of you.

**10** Into that space, if it feels okay, you are going to welcome a question: what do I most need from my art practice today?

**11** Into that space, the answer might appear in the form of an image, a color or a shape. It might be a feeling, a texture, a temperature or a sensation. It might be a sound or a smell.

**12** Whatever it is, even if it doesn't make sense, if it feels okay, go ahead and welcome it. You don't need to understand it.

**13** Perhaps just sit with the answer for a minute. When it feels like it's as clear as it will be in this moment, you can offer it some gratitude and let it go.

**14** Begin to welcome a little more movement into your body by taking deeper breaths, perhaps even with another sigh. Feel the air pushing your chest and belly outward.

**15** Give yourself permission to make any movements that feel comforting right now—wiggle your toes, gently squeeze your hands, roll your shoulders and then allow your eyes to open gently.

**16** Now slowly and gently pick up your pen, and begin your slow drawing, continuing to notice what you feel, hear and see as you draw.

# Drawing with Curiosity

These warm-up exercises are experiments to explore drawing with curiosity. We will explore several short drawings. We're not making art. We're noticing what it's like to move a pen across a page. It's a simple task, but some days it can be tricky. At the end, we'll do some reflective writing to help you learn about your particular slow drawing approach.

**Materials:** Pen, 5 sheets of computer paper and a timer

## Nondominant-Hand Blind Scribble

Without looking at the page, we're going to do some blind scribbling with our nondominant hand. You can hold the page steady with your other hand. Any time your pen runs off the page, don't worry, just feel around and get back on. You can place a larger sheet of paper or cardboard under your page to protect your table from scribbles. Remember, our purpose is not to make art, but to notice what it feels like to move the pen.

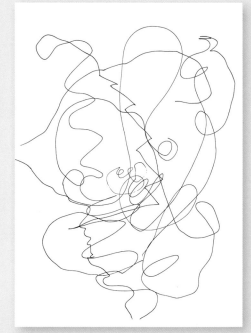

1. **Set a timer** for 1 minute.

2. **Close your eyes** or look at the opposite side of the room, so you don't peek at the page.

3. **Allow the pen to explore the page** in whatever way feels good. Get curious about the movements your hand wants to make, and do those, even if it seems weird or ugly. (This usually means you are on the right track.) Keep the pen moving in one continuous line.

4. **As you work, get curious** about what you notice through the senses. What is the texture of the paper under your hand and the sound of the pen moving across the page? Can you feel your breath moving your belly in and out? What is the temperature and texture of the pen in your hand?

5. **When the timer goes off**, open your eyes and set the nondominant-hand scribble aside.

## Blind Scribbling Like a Squirrel

1. **Set a timer** for 1 minute.

2. **Close your eyes** or look at the opposite side of the room, so you don't peek at the page. You can use either hand for this particular exercise.

3. **Pretend that your pen is a squirrel** in the woods, moving with frenetic energy across the page.

4. **As you work, get curious** about what you notice through the senses. What is it like to move like a squirrel? Do you hear the sound of the pen moving across the page? Can you hear your breath?

5. **When the timer goes off**, open your eyes and set the squirrel scribble aside.

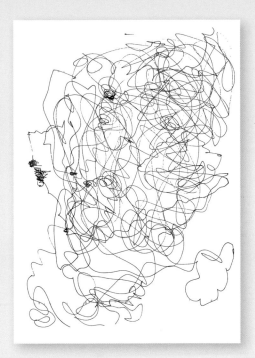

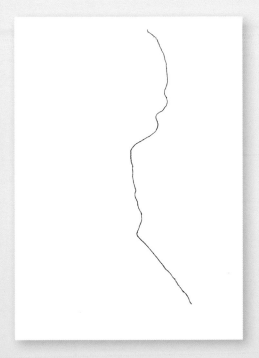

## Blind Scribbling Like a Snail

1. **Set a timer** for 1 minute.

2. **Close your eyes** or look at the opposite side of the room, so you don't peek at the page. You can use either hand for this particular exercise.

3. **Pretend that your pen is a snail** in the woods, inching its way along a log.

4. **Let go of the goal of drawing** a certain amount, and just tune in to what it feels like to draw slowly. As you work, get curious about what you hear, feel, see or smell. What does your grip feel like on the pen? Can you feel the texture of the page resisting as you slowly move?

5. **When the timer goes off**, open your eyes and set the snail scribble aside.

## Blind Scribbling at a Comfortable Pace

1. **Set a timer** for 2 minutes.

2. **Close your eyes** or look at the opposite side of the room, so you don't peek at the page. You can use either hand for this particular exercise.

3. **Thinking about the squirrel and the snail** (see previous page), pick a speed somewhere between the pace of those two creatures that feels comfortable in your body.

4. **As you draw, get curious** about your experience. What does this pace feel like? What's different between this pace and the others? What do you hear, feel, see or smell?

5. **When the timer goes off**, open your eyes and set the comfortable-paced scribble aside.

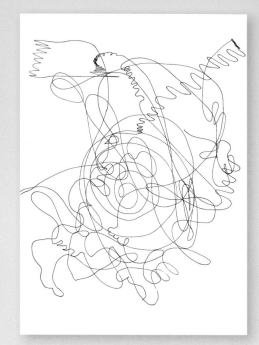

# Questions for Reflection

Set your drawings out in front of you in chronological order. Set a timer for 5–10 minutes, then write down answers to the following questions:

· How would you describe the way the different paces of drawing felt in your body?
· What did you notice through your senses while you drew?
· Which drawings felt relaxing? Which felt frustrating?
· Did any associations come to mind as you drew?
· What did you learn in these exercises that you might be able to bring to your creative practice?

The experience of drawing with curiosity is a bit different for everyone. Many of my students say that when they first do these exercises, it feels painful to go slow. This makes sense. Everything in our culture pushes us to move faster and produce more, so slowing down can be really uncomfortable at first. Be patient and compassionate with yourself. Many of my students note that by the second or third round of slow drawing practice, they relax into a slower rhythm and it feels surprisingly good.

If you struggle to slow down, you might need to draw a bit faster the first number of times, and then gradually invite yourself to slow down. Slow drawing is a practice in which you don't have to perform—you can just explore and do what feels good on any given day. This practice is about nurturing yourself. Tune in, notice what feels good to you and honor that.

# Looking for Inspiration in Nature

Going on a nature walk, no matter what time of year, is an opportunity for me to slow down and look deeply at natural objects. I can't tell you how important this is to my well-being and creativity. Since the woods are most accessible to my home, I usually walk in the forest, though I do get the occasional trip to the mountains or the ocean, too. I try to weave nature walking into my week, on occasion spending as long as an hour or two doing this, but most often I take shorter walks. Even 15–20 minutes in the woods does me a lot of good. As I've made it a habit, I have the sense that I'm being welcomed every time I walk in nature. I take my place—a curious, quiet creature who absorbs the sights, sounds and beauty of the forest.

I move slowly, paying attention through my senses. I hear chittering, crunching, rippling. I feel crispy lichen on trees and soft, velvety mushrooms. I'm humbled by towering trees and vast mossy carpets. The textures, colors, sounds and sensations bring me directly into the moment, where my eyes are opened to the beauty all around me.

The more I engage in nature walks and slow drawing, the more grounded I feel when I'm in nature or making art, but at other moments too. I still get tuned out, short-tempered and anxious, but less so than before. That's no small thing.

Finally, mindful nature walks inspire my art, which gives me joy and meaning. I linger, looking at a dried leaf—sinewy, turning in on itself. I imagine the way it curled into position as it embraced the last moments of life. These lines, forms and ideas find their way into my art. Nature offers us never-ending opportunities to marvel, to study, to feel. Nature creates unnecessarily beautiful objects on every scale, from microscopic plankton to soaring mountain ranges. Let's take nature up on its offer of inspiration.

Here are some of my tips for drawing inspiration from nature. If you live in a more urban environment, you can participate by going to the local park, or even slowly studying the plants and trees in your backyard or local neighborhood. Nature is all around us if we are willing to slow down and look.

## Go for a Slow Nature Walk

**1.** Go for a slow walk in a natural space—even 10–15 minutes can make a difference to how you feel and inspire your work.

**2.** Walk very slowly, paying attention through your senses and stopping often to look. Just as in slow drawing, notice what you hear, see, smell and feel in this environment.

**3.** Pay attention to what surprises you, what delights you and what catches your eye.

**4.** Be open to finding beauty in the natural world. Look at the tiniest details of a leaf and the grand sweep of the landscape.

**5.** Be curious. Look at an object as if you've never seen it before. Look closely at the pattern of a pine cone, the way the blades slant upward and gently curve in on the sides, creating a slide for raindrops.

**6.** When you find something that piques your interest, and after you've studied it slowly for a long time, take several photographs of it. Look from different angles: from above, to the left, right and underneath. Get as many different views as possible.

**7.** If there's not a scarcity of your object of interest, respectfully gather just one. (For further advice and information on the respectful harvesting of natural objects, see *Braiding Sweetgrass* by Robin Wall Kimmerer, a book I love and highly recommend.)

**8.** If you bring a small notebook and pen on your walk, you can sketch your object, capturing its essence or pattern. Don't try to make this good, just capture your ideas.

## Play with Patterns

Here's some ways to play with the patterns and lines you might find. When you're home, sit down at your art table with several pieces of scrap watercolor paper, a drawing pen, watercolor paints and paintbrush, and your photos, chosen object and sketches.

**1.** Start by making some exploratory sketches of what you see. Pick out outlines, details in the center of things and patterns. As always, first and foremost, engage in slow drawing. Take your time and notice through all your senses as you draw.

**2.** Use multiple angles, both from the photos you took and from the object itself if you have it.

**3.** Don't worry about what makes sense or looks "good"—just focus on what feels fun to draw.

**4.** Once you land on the first idea that you enjoy (and I say first because there will be several if you keep at it), explore 5 different ways of rendering this pattern, one per card. They may look a lot like the object that inspired them, or nothing at all.

**5.** From these 5 variations, pick one you like and repeat it 5 more times. When you make several similar ones, it gives you space to play with the results without fear of "ruining" it.

**6.** Now make 5 new variations, and then 5 iterations of your favorite one.

**7.** You can keep repeating this process as many times as you like. In fact, the more times you find new shapes or iterations in a pattern, the further you stretch your creative muscles, and the better the work you'll be able to produce. As always, go slow. You'll hear the ideas from your imagination more clearly if there's space for them to speak.

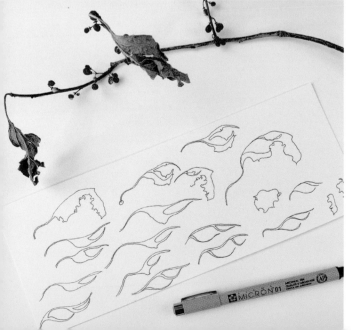

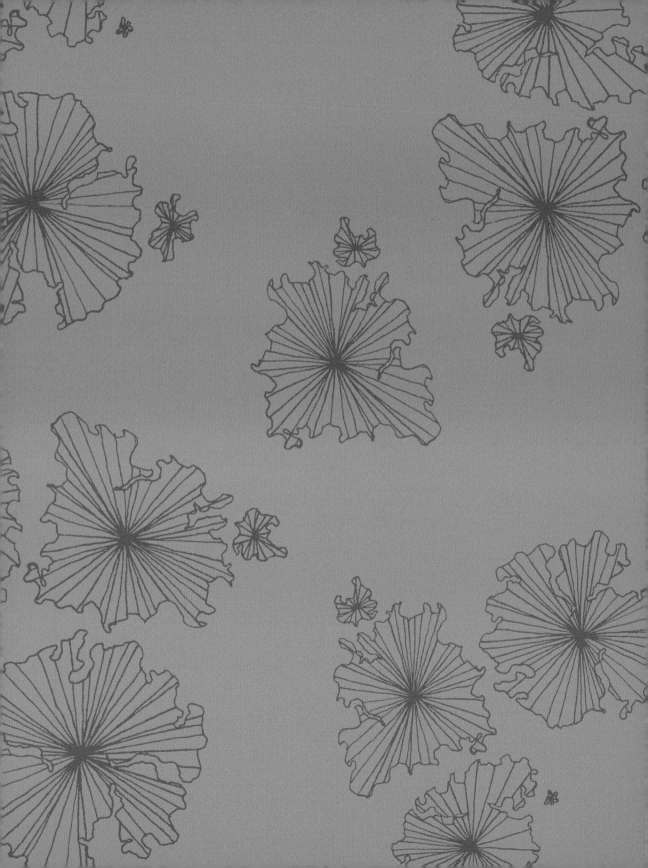

# Slow drawing
# patterns

You'll find all the slow drawing patterns in this
section, with guided steps so you can be present
and find your rhythm with this easy and fulfilling
mark-making practice. You can flip through the
pages and start on a random page, or with a
pattern you are instinctively drawn to.

# Slowing Down and Tuning In Through the Senses: Fan Pattern

As we dive into our first slow drawing pattern, Fan, my invitation is for you to focus more on the physical sensations of drawing than the drawing itself. The easiest way I know to do this is to draw your lines in a slow, gentle way. At our normal drawing pace, everything happens too fast, and it's hard to track what we are feeling, hearing and seeing as we draw.

When you first begin slow drawing, moving slowly might feel unfamiliar and therefore uncomfortable. Frequently, students tell me they feel a bit anxious when they begin, but, as they give themselves permission to slow down, their breath deepens, their grip relaxes and they fall into the rhythm of repetitive, gentle drawing.

Stay curious about finding the slow drawing rhythm that feels right for your body. This may shift over time or even from day to day. Let your wisdom be your guide—if going slow really doesn't feel okay for you, trust that. But if you think there's room for exploration, try slowing down even more than you think you should. As you slow your pace, and let go of the need to perform, you can begin playing with noticing through the senses. What does the pen feel like in your hand? Is it cool or warm? Smooth or rough? Can you hear your breath? Can you see the ink sitting shiny and wet when it first meets the page and then dulling as it seeps into the paper? It's beautiful to notice these details.

There's so much beauty happening all the time, but we miss a lot of it because we're moving too fast. You may find the right pace for you is much slower than you expected. The funny part is, the more we let go of the need to be "productive" and make "good art," the more it opens up our creative channels, allowing the patterns and images to evolve, which in turn makes us want to slow draw more.

And if, like me, you struggle with some perfectionistic tendencies, I want to invite you to try to find the sweet spot between challenging yourself to step out of your comfort zone and pushing too hard. I want this to be a nurturing, relaxing practice—a time that is just for you and your creativity. There's no right or wrong, just what feels good for you. I'm offering what works for me and many of my students, but each person and each body is unique. Please take what works for you and let go of anything that doesn't. If you do that, you're doing it right.

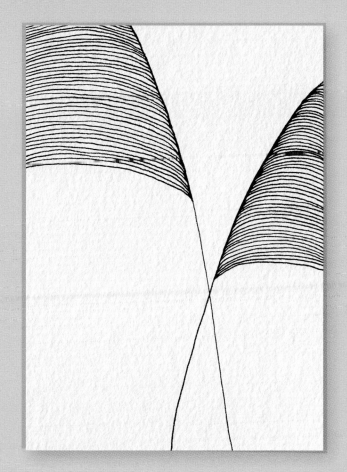

**1** Draw a long, curved line from one side of the page to the bottom.

**2** Starting just below the halfway point of the line, draw a curve out to the edge of the page, so it creates a sort of triangle or cut-off leaf shape.

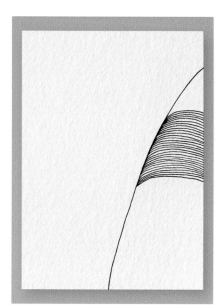

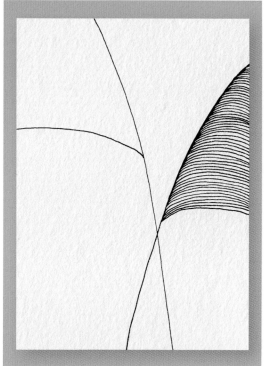

**3** Starting near the point of the triangle, echo the line you drew in step 2 and draw more lines close together until you have completely filled in the shape, creating a sort of fan.

**4** Draw a second fan shape on the page, either near or opposite the first. Here, I have drawn a larger fan on the left-hand side.

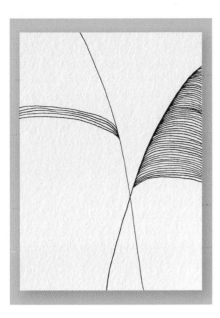

**5** Repeat this process several times with variations on different pieces of paper and explore what you like.

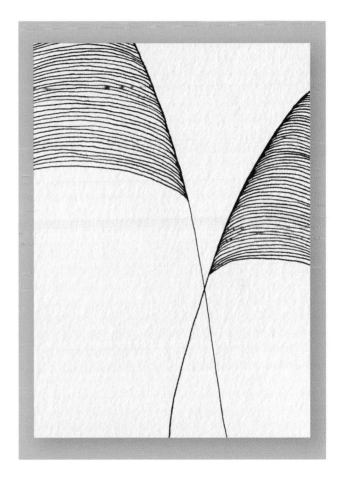

## Variations to try:

- Experiment with drawing just one fan per page or numerous fans.
- Play around with overlapping the fan shapes.
- See what happens if you draw multiple fan shapes with all the "stems" at the top of the page instead of the bottom.
- Use watercolor paint to fill in the white space between the fans.
- Draw a painted background using colorful paint pens or gel pens.

# Asking "What if...?"
# Cobble Pattern

Slow drawing is a beautiful, meandering journey. It's your chance to go on an adventure with a series of small shapes. "What if...?" is a powerful question that will set you off in new directions. It helps you engage your curiosity and detach from judgment. You might ask questions like: What if I turned my paper every few marks? What if I did six different variations of this pattern? What if I drew like I was three years old?

When you first try a pattern, it can be helpful to follow the steps on the next pages to become familiar with how the pattern works. But my intention in this book, and as a teacher in general, is not to teach you to copy. I want you to see your creative practice as a journey and an adventure. Asking "What if...?" is a powerful way to bring your attention to the moment. Watch the lines appear, listen to the pen moving on the page and marvel at what develops. The more you get into a curious state, and out of a judgmental state, the more space you make for calm, creativity and your unique voice.

I invite you to take each "What if...?" question—whether mine or your own—and fully explore it. Repetition is key. It helps you improve your skills, work out your ideas and find your rhythm. Sometimes I like a particular version of a pattern so much that I will make several so I can use it in multiple ways, without fear of "ruining" it.

The Cobble pattern is a collection of imperfect, wonky, stone-like shapes. You can vary the sizes and shapes or keep them uniform. I find it fun to fill in the cobbles with watercolors in warm earth tones, but please explore and see what works for you.

## Generating New Ideas

Write a list of 10 "What if...?" Cobble questions—these will provide you with a list of pattern variation experiments. Here's a few ideas to get the ball rolling: What if you drew lots of cobblestones on the page or just a few? Or placed them very close or very far away from each other? What if you pretended you could lift the page and shake all the cobblestones down to the bottom, or if you spaced them evenly on a grid? Do as many of the Cobble experiments as you feel curious about.

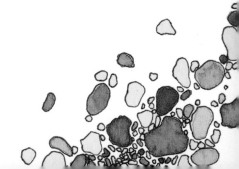

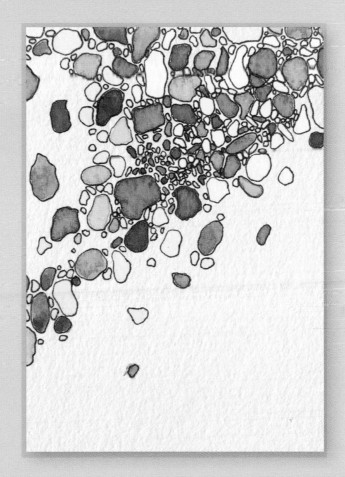

**1** Draw a cluster of 3–4 imperfect circles and ovals of roughly the same size. Most stones are not perfectly round, oval or square, so wonkiness makes them look and feel more realistic.

**2** Now create another cluster of stone shapes to the side or underneath the first. Repeat this process several times. Keep drawing in this way until a path begins to take shape across the page.

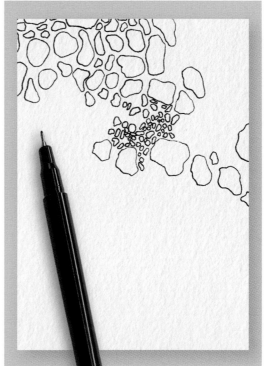

**3** Feel your way through the path, focusing on the process of drawing rather than the product. Notice the way the page drinks in the ink as you move your pen.

**4** You might wish to begin filling some of the spaces between the stones with a series of tiny pebbles. The pebbles are also imperfect circles and ovals, just smaller. They create contrast, depth and texture.

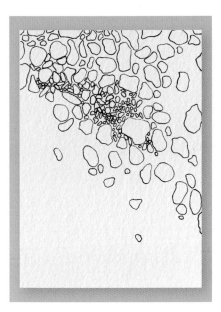

5 When and if you feel yourself speeding up, loosen your grip, take a deep breath and gently draw the next shape. Notice what it feels like to draw slowly and with intention instead of rushing and judging yourself or your art. Your task is to draw slowly and with curiosity. The art will naturally improve as you focus on slow drawing.

6 You can dance between focusing on process and seeing where the next shape goes. Periodically, hold the paper at arm's length or turn it around. Your drawings will look very different when you hold them a couple of feet away or just inches from your face.

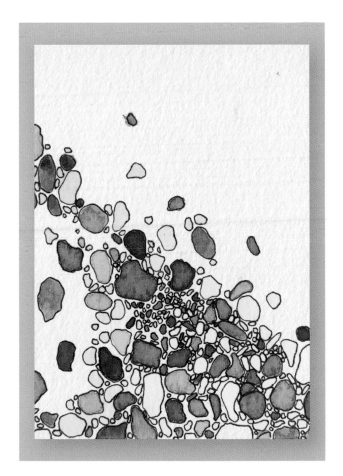

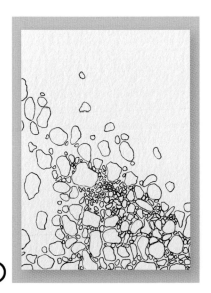

7 Leave the drawing black and white or add some watercolor. I like to use 2–3 similar colors for a calming palette. I vary the color I use in each section and leave many areas white to create contrast. Experiment to find the most pleasing colors.

# Be an Art Explorer: Twist Pattern

You may sometimes feel judgmental about your art. This may even get in the way of you making anything. Given the emphasis that Western society places on productivity and perfectionism, I think it's natural to feel this way. I'd love to offer you a different approach. Slow drawing invites us to show up, observe and watch what wants to emerge on the page. Art can be playful, freeing. Let yourself be driven by a sense of curiosity and adventure, not judgment. For me, practicing not being in control at times is a relief. Drawing lines on little pieces of paper isn't dangerous, expensive or time-consuming. It's a safe way to let go a little bit and see how this affects my art and my life. I find that creating art in this way helps me let go of judgment and perfectionism, and nourish myself with the joy of making art.

As an art explorer, your job is not to make "good art," but to be curious about the possibilities. I like to pretend that my pen is the explorer and the paper is a vast landscape. If you wish, you could experiment with letting the pen go wherever it wants to on the page. Explore what happens when you release all pressure to make "art," and instead give yourself permission to just make something, even something ugly. (You'll be amazed at what happens when you do this.) As an art explorer, your main goal is not to make something beautiful, but rather to push the limits and discover as much as you can by trying things in different ways. The beauty of this approach is that the more you let go of control and tune in to what feels fun, adventurous or relaxing to draw, the more your drawing will improve.

The Twist pattern calls for a flowing, relaxing movement. Your only job is to be as adventurous as possible with the Twist pattern, trying it out in different ways. Let your hand and pen slowly experience the space and go on some adventures.

## Carry a Portable Art Kit

One of the best ways I know to tempt myself to draw more often is to carry a portable art kit. I carry a small zip pouch containing a drawing pen and several small pieces of watercolor paper. I bring a combination of blank pages and drawings in process, so that regardless of my mood or the amount of time available, I have a place to start. I try to slot this practice into some of the "in-between" moments in my life—waiting to pick up kids, sitting in the waiting room for doctor's appointments or while water is boiling. I find any time I might feel tempted to pick up my phone is often a good time to spend a few minutes slow drawing and, usually, it's an activity that feels much more calm and meaningful than checking my e-mail.

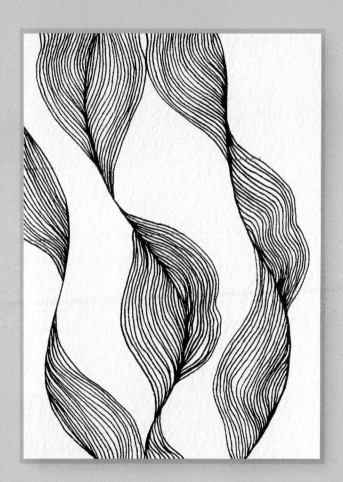

1 Slowly draw a vertical "wave" from the top of the page to the bottom.

2 Notice how there are "hills" and "valleys" in the line? Pick one of the valleys and draw an arch shape over the top, to create a leaf or a mountain shape. You may want to turn the paper horizontally to make it easier to draw this.

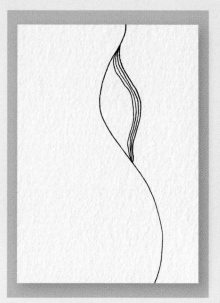

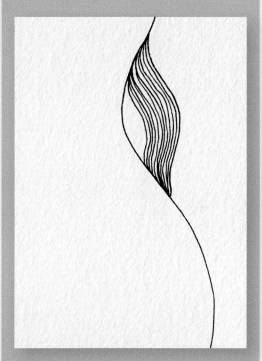

3 Echo the arch shape with more lines, keeping these close together and fairly evenly spaced.

4 Keep adding lines until you reach the bottom of the valley, then repeat this step for any other valleys in the line.

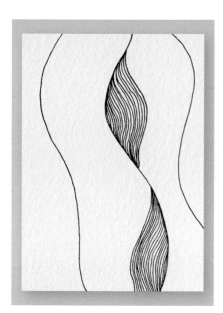

**5** Add a second, third and possibly fourth curving line on the page, and then repeat steps 2–4. Remember to think about drawing gently—this can help you draw more slowly.

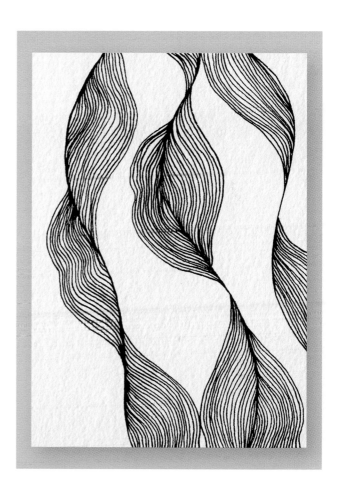

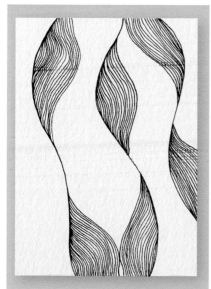

**6** For a fuller effect, you might like to create an arch or undulating edge both in the valley and on the mountain side of your main lines. Then echo the lines on each side as you did in steps 3 and 4.

**7** You can also experiment with drawing an undulating line that resembles the edge of a large piece of seaweed, or perhaps a ruffled collar, instead of an arch. Now echo that line with more rows of lines to fill the space.

# Where is Your Edge?
## Edge Pattern

The inspiration for this pattern is the edges of flower petals and mountains—they have beautiful dips, heights and ridges that create interesting lines. I love the way nature's patterns repeat. It's fascinating that the edge of a nearly weightless, paper-thin flower petal and the massive form of a mountain edge mirror one another, isn't it?

As you draw edges, you might allow your imagination to speak to you about the boundaries you are pushing with slow drawing. Could you give yourself permission to draw something "ugly" in order to create more freely? Could you experiment with drawing for five minutes each day at lunchtime for one week? What about experimenting to see how slowly you can draw while still keeping the pen moving? Have fun with the idea of edges, and see what types of experiment feel good to you.

Give yourself permission to take your time, draw slowly and enjoy the practice. Remember, I invite you to make multiple drawings of the same pattern, so you'll have lots of space to practice and explore each one.

If the slow pace initially feels uncomfortable, see what happens when you don't fight that feeling, but just notice and acknowledge it instead. Notice if the uncomfortable feelings diminish over time. Sometimes things can feel uncomfortable, not because they aren't good for us, but because they are unfamiliar. You can tune in to your body and see what feels right for you.

### Think About Your Edges

The Edge pattern brings up some powerful metaphors. Edges suggest limits, fear and growth. For me, practicing slow drawing helps me push the boundaries of mindfulness in art and, increasingly, in other parts of my life. I am schedule-oriented and feel uncomfortable with being late. This makes me feel stressed out and uptight, and I sometimes lose my temper. Slow drawing has helped me slow down and be more present. It creates space for me to notice my reactions and ask myself: Why am I rushing? What am I feeling? Slowing down, just as I do when I draw, helps me make a conscious choice to be more grounded and calm.

You might find slowing down and slow drawing challenging. Making time for a creative life can feel self-indulgent, and you may try to make as many cards as possible to be "productive." But rushing keeps us from hearing the wonderful ideas bubbling up from the imagination and from forming careful lines. Going fast is often a quick path to slow progress with slow drawing.

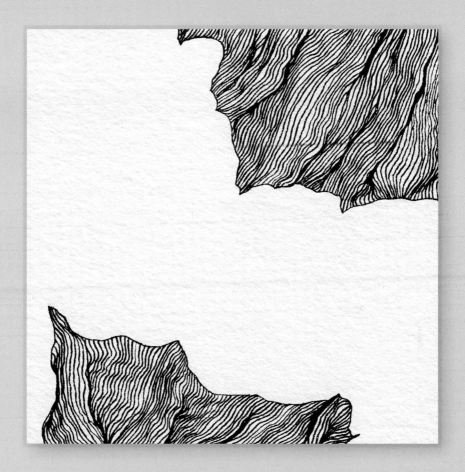

1 Begin by drawing a bumpy line with a combination of points and rounded parts, creating a shape that recalls the edge of a flower petal or mountain range. Start at the left-hand edge of the page and draw the line to the bottom-right edge of the page.

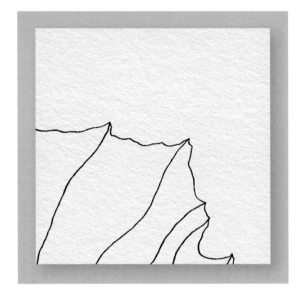

2 Next, identify the points in the edge line you've just drawn. For each point, draw a wavy line from the inside of the point to the bottom of the page. This creates sections within which you will draw later. I find breaking the shape into parts in this way helps me to visualize where the drawing is going.

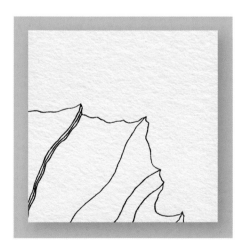

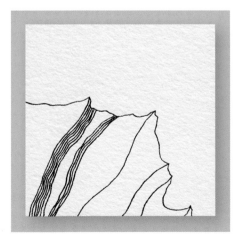

4 If a section is large, I often add an extra line in the middle to make it feel more manageable. Or I draw from both sides of a section toward the center until I fill it in completely. Experiment and see what works best for you.

3 Choose a line and draw another one right next to it. Repeat this a few times. Place your pen on the line slowly so you don't cross over. If you do, just embrace the beauty of imperfection.

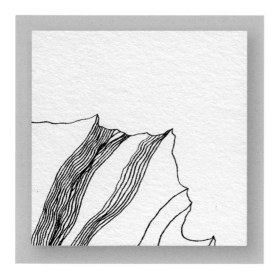

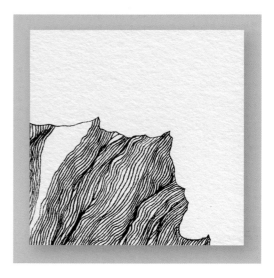

5  As the lines are wavy, they will meet in some places and not in others. In the sections where the lines overlap, the ink gets darker and creates the impression that there are "folds" in the petals or mountain. These folds may happen at the bottom, middle or top of the shape, or in all three places. Just have a play and see what emerges.

6  Now, move on to the next section and begin filling it in with wavy lines as before. There's no right or wrong way to draw the lines within the shape. Experiment and see what feels good to draw. Continue drawing in this way until you have filled in all the sections.

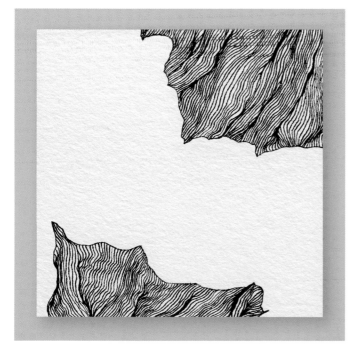

7  You may wish to have just one edge shape on the page or opt for two or more. For the second edge shape here, I've followed the same steps as for the first, but this time I've started and stopped my edge line at the bottom of the page. As always, feel free to vary the drawing or composition, as it's part of finding your unique interpretation of this pattern.

If you wish to explore this drawing further, see pages 47, 49, 79, and 131 for creative variations.

# Finding Your Own Way: Innovate

One of the most important lessons I hope to offer in this book is that of making this practice and the patterns your own. Drawing from someone else's work can be fun and relaxing, and if that's all you want, then I'm pleased to offer it. But if you are looking for a sustained creative practice, one that can both ground and energize you, you'll want to go further. Wander out into the wilds of your imagination—the space that opens up once you relax into noticing the movement of your pen and the sound of your breath.

Complete many variations of each pattern. Draw it 5, 10 or 25 times. Seek new connections to nature and your interests, and let what feels good dictate your movements and lines. The more times you draw each pattern, the more it will change, becoming a reflection of you. Seeing yourself in this way can be a thrilling affirmation.

If you already have ideas about how to approach making these patterns your own, stop reading and start drawing. You don't want to confuse your creative instincts with my suggestions. You can always come back and play with some of these ideas after you've explored your own.

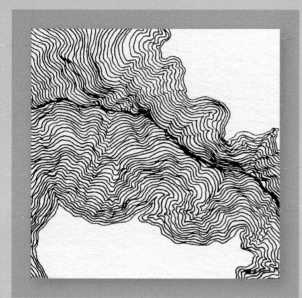

Variation on Edge (page 42).

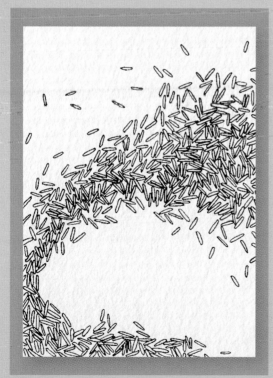

Rice (page 118) clustered into a sideways U-shape.

## Frameworks for Innovation

If you need help to get started, I'd love to share some frameworks to help you take the patterns in new directions. Regard my examples not as directives, but as an explanation to spark your imagination. Think about how to apply these ideas to one of your favorite patterns. As you read the suggestions, take a piece of paper and pen and jot down the ideas that come to mind. Set an alarm for 5–10 minutes and give yourself time to elaborate on these ideas in both writing and sketches.

· Draw the pattern, but prioritize drawing what feels good rather than what looks good, even if it's a mess. Trust that it's relaxing, and there could be something interesting in it for a future drawing.

· Change the scale of the pattern. If it's small, make it bigger, and vice versa. Imagine a close-up version of the *Milkweed* pattern (page 62) or super-tiny *Wave* pattern (page 110), for example.

· Combine two different patterns. You could surround one pattern with another, overlap them, or take part of one pattern and combine it with part of another. For example, take the vine-like lines of *Wander* (page 132) and connect clusters of *Cells* (page 92) where the leaves should be.

· Turn the pattern inside out. For example, I took the Edge pattern and traced the lines above the form instead of within it.

· Create interesting shapes in negative spaces. I love to make little circles or ovals of negative space by surrounding them with *Rice* (page 118), *Mussel* (page 114), *Squiggle* (page 100) or *Fish* (page 80) patterns.

· Trace a natural object, such as a stone or shell, and draw a pattern around it. Write text or draw another pattern in the middle.

· Extrapolate the basic form from a pattern and do something new with it. For example, you could take the long lines from *Wave* and make long, flowing ribbons, or perhaps place multiple ovals inside circles.

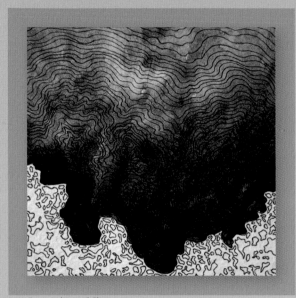

Kelp Pattern (page 96) with echo lines and ink wash.

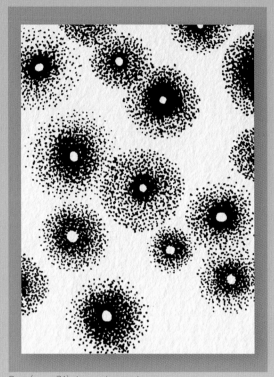

Dots (page 74) clustered around negative spaces.

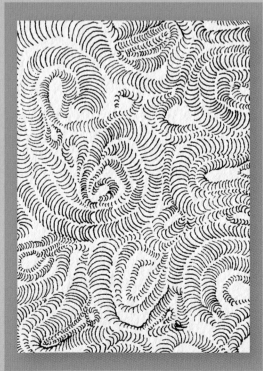

C-shapes repeated.

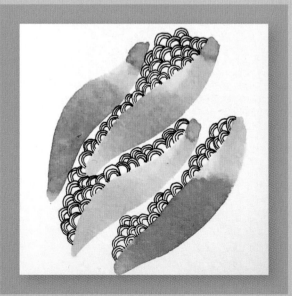

C-shapes nested between watercolor strokes.

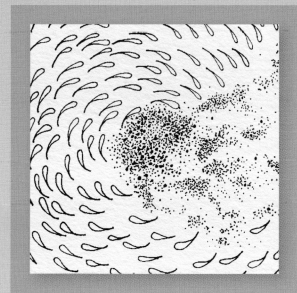

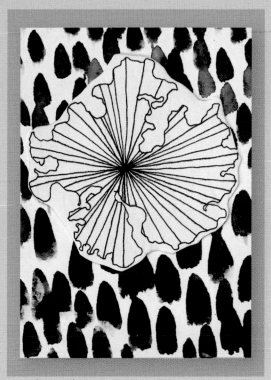

Fish (page 80) with Dot (page 74) clusters.

Lichen (page 88) with a background of brush marks.

Edge (page 42) made into flower petals.

Wave (page 110) arranged into ribbons.

# Don't Make Art:
# Chicken Scratch Pattern

Chicken Scratch is one of my favorite patterns because it invites you into a playful drawing process. The idea of moving like a chicken—pecking, running and bobbing about—has always brought a smile to my face. It helps me to stop focusing on making "good art," and instead to play on paper. If you have a strong inner critic, this pattern might be a particularly good place to start.

## Use Chicken Scratch as a Background

With your eyes closed, use a white gel pen to make the Chicken Scratch pattern on a piece of watercolor paper. Once the pattern is dry, paint over it with a light coat of watercolor paint, and watch your marks reappear. I love to use this textured page as a background for other drawings, collage or quotes in my art journal.

The process of making art can be deeply satisfying when you allow in some mystery and discovery. This exploration leads to those gem-like pieces of art you see on the walls of a gallery. Give yourself permission not to make art, but to explore. The marks I've made with the Chicken Scratch pattern are some of my favorites. They are free and wild, and teach me about the creativity that lurks in me when I allow myself to let go. There's no getting this wrong. Just play.

**1** Make sure to have 8–10 cards ready on your table.

**2** Place the first card in front of you with a sheet of scrap paper underneath in case your pen runs off the card. You'll be drawing this pattern with your eyes closed.

**4** When you feel ready, imagine a chicken roaming in a grassy yard. Get curious about your chicken. How does it move? Where does it go? What is it doing? Do this for a minute or two, or longer if that feels good.

**3** Take a moment to close your eyes and breathe. Notice what it feels like to sit in your chair and just be present.

**5** With your eyes closed, pick up a pen and record the movements of the chicken on your page. When it pecks at the ground, use the pen to peck; when it turns left, then right, so does your pen. If it runs in circles like a... well, you know, then your pen does that too.

**6** After a few moments, set aside your card and start work on a second card, a third and so on. Complete the entire stack with your eyes closed. Try to resist the temptation to peek—it's fun to see them all at the end with a fresh pair of eyes.

**7** As you examine all your cards, notice which shapes and textures speak to you the most.

**8** With your eyes closed, draw another card that only focuses on one of the marks that spoke to you. If this feels okay, try to push your limits a bit and let your imagination roam freely.

# Using Negative Space: Bend Pattern

One of the ways we can make art more fun and interesting is to play with negative space. Negative space is simply the space on the page where you don't draw anything. With the Bend pattern, it's all the spaces between and around the thin, bent oval shapes. Just like your drawing subject, negative space has a shape too, and affects the mood of your art. As an example, let's imagine two canvases. In the first canvas you see the inside of a subway car—people are jammed in, much too close together. On the second, a woman stands to the right in the lower third of the canvas, with one hand cupping an invisible bar and the other holding a coffee cup. Around her is nothing but white space. See how different that feels?

The basis of the Bend pattern is a long, skinny oval that bends in one direction or the other. As always, there's no right or wrong way to explore this pattern, but I'll walk you through the way I drew it in the example shown here.

## Play with Negative Shapes

As I draw, I often like to focus on the negative shapes I'm creating. The Bend pattern is like a C-shape that makes a bowl in its negative space. You might wish to explore what you can do with these bowls. For example, you could try making a row of negative-shape bowls around the perimeter of the page. Or you might create a series of negative-shape bowls facing each other, so they look like broken circles or ovals. See how imaginative you can be when you start playing with the shapes in the negative spaces. You can use this trick not only with the Bend pattern, but with any of the patterns in the book. See how many different ways you can explore the negative space.

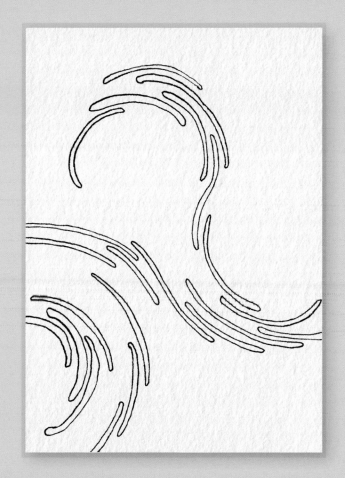

1 Begin by drawing a long, skinny oval that arcs from the edge of the page downwards.

2 Now draw another skinny oval just above it, staggered slightly ahead of the first. Then, draw a third just ahead of and below the second. See how the shapes are creating a half-circle in the negative space?

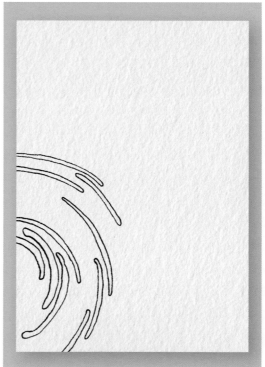

3 Draw a fourth bent oval so it hovers just above the others. The next time you layer a group of bent shapes, let them bend out toward the right side of the page. The aim is to keep staggering the ovals to create interesting shapes in the negative space between ovals.

4 Stagger another series of bent shapes to the right of the group you just made. Repeat with more bent shapes slightly above. In the next step, you'll add more shapes across the page, but inverted the other way.

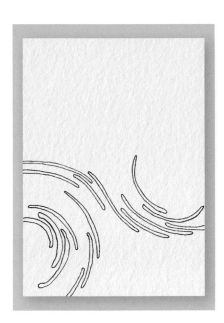

**5** Layer another series of bent shapes on top of and to the right of the previous ones, so they look like an open bowl.

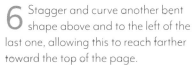

**6** Stagger and curve another bent shape above and to the left of the last one, allowing this to reach farther toward the top of the page.

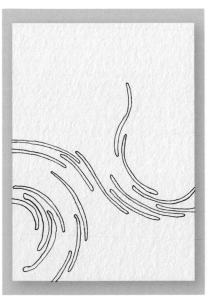

**7** Continue layering and staggering bent shapes in this way. You may find it helpful to turn your page periodically to get a new perspective. Sometimes this will change the orientation of the drawing, which can be a fun surprise.

# Locating Your Breath:
# Exhale Pattern

When was the last time you blew on the plumes of a dandelion? You can close your eyes and imagine it: you gently pick the flower and then take a deep breath. Slowly, carefully, you blow out a thin stream of air that sends the seeds floating. Breathing is automatic; we breathe without giving it any thought at all. The Exhale pattern is an invitation to bring some attention and intention to your breathing.

A good way to begin is to become curious about your breath. You can ask yourself things like: Where is my breath in my body right now? Can I feel it in my nostrils? In my chest? Does it push on my belly or my ribs? Know that there isn't a right or wrong answer here. The goal is to practice noticing. I noticed that just as with slow drawing, over time I got better at tuning in to the breath. Now, when I tune in to it, it calms me much more quickly.

## Breathe and Draw

You might experiment with joining the breath to your lines as you draw. On each exhale, draw a line, and on each inhale, draw a dot. Be playful with this, and find a way to draw the breath that brings you comfort. At first, it might help to focus more on the breath than the accuracy of the drawing. You might wish to write a bit about your experience too. This kind of reflection can solidify your learning and nudge you forward.

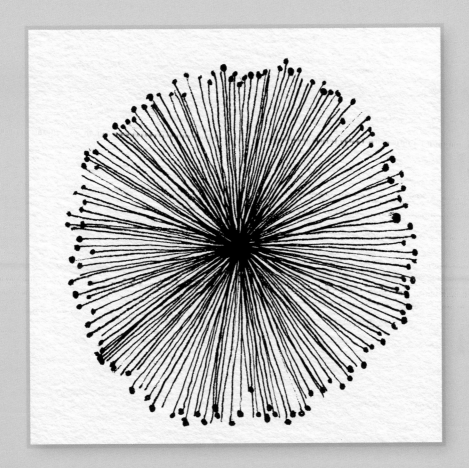

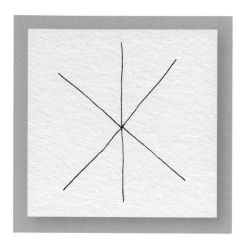

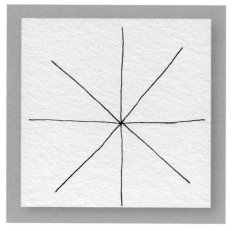

2 Draw 2 more lines from the middle to the left and right sides of the page. Your shape will look something like an asterisk. This is the basic form to which you'll add lots more lines.

1 Begin by drawing a line from roughly the middle of the page toward each of the 4 corners. Next draw a line from the middle to the top and bottom of the page.

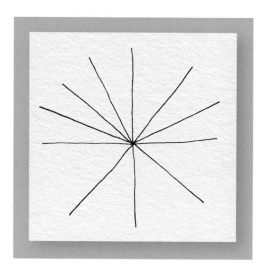

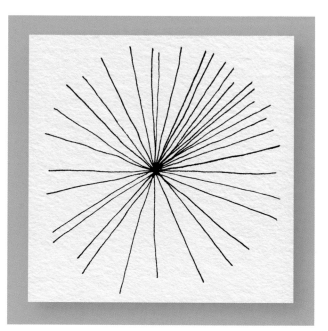

3 In any of the sections you've created, begin drawing lines of more or less the same length until you have filled in the section. I like to jump around, from section to section, so I can watch the form take shape and not overdo it.

4 Keep subdividing each section, allowing some lines to be a bit longer and some a bit shorter. This will create a sense of depth as some of the lines will seem closer and others farther away.

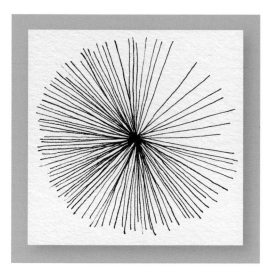

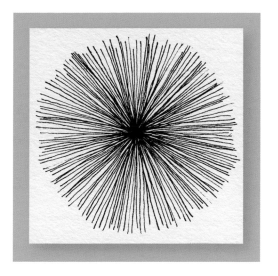

5 Remember to draw slowly. This pattern is deceivingly simple and you might find yourself speeding up. If this happens, just gently bring your attention back to your breath.

6 As the form begins to emerge, become curious about where the next line wants to appear, rather than trying to think where to place it. Notice what happens as the ink builds up in the center of the shape. You may find that grooves develop, and it's easier to draw from the outside in, instead of from the inside out.

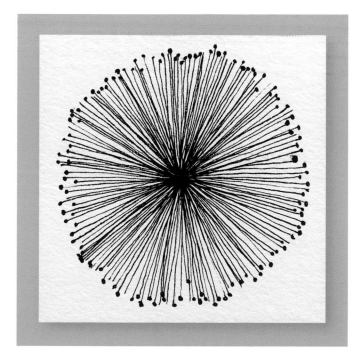

7 When you feel that you have all the lines you need, or even a little before this stage, start adding dots to the ends of the lines, perhaps skipping a few to give a more natural feel.

# How Gently Can You Draw?
# Milkweed Pattern

Milkweed is a pattern you might like to try with a pen that is drying out. The more lightly you draw the lines, the easier it is to mimic the super-fine floss of milkweed pod seeds. Try using the smallest nib you have—I've used an 001 here, but I enjoy using an 005 or 003 sometimes, too.

I love drawing the Milkweed pattern—the lines are light and airy and it's an excellent opportunity to explore your touch as an artist. There can be a tendency to hold the pen with a "death grip," especially in people who are new to drawing. Rather than trying to force the pen and lines into submission, I invite you to explore what happens when you draw gently. Try holding your pen as though you might hold a baby bird. What does a whispered line look like? How does it feel to draw in this way?

After you practice drawing like this for a while, sit back and notice how different grips affect the quality of your lines. Practice looking at the lines as if they were made by someone else. It will help you see them more honestly, without the negativity of your inner critic.

## Start with a Warm-Up

With a gentle grip, practice creating light, airy lines that whisper onto the page; the pen might even lose contact at times. Let some of the lines curve this way and others that way. Keep doing this until you start to feel comfortable creating these silk-like lines. It takes practice, but once you practice for a bit and catch on, it's a fun skill to use in your drawings.

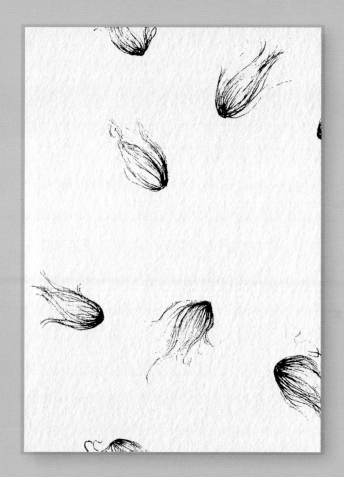

1 Begin by drawing a small oval as the base of the first seed.

2 Draw a slightly curved line that extends from the base of the seed upward. Do this a few times in a small area to create a clump of silk.

3 Repeat this process on the other side of the seed as well, but this time make sure the lines curve the other way.

4 Next, use curved lines to fill in toward the middle of the seed base. You may want to draw a few very light wisps of silk that curl out at odd angles.

**5** Draw more than one milkweed seed form on the page and vary your pattern: make some seeds clumpy and some more unified, like a puff. Remember to curve the lines to give a sense of volume and movement. Experiment here to see what looks beautiful to your eye.

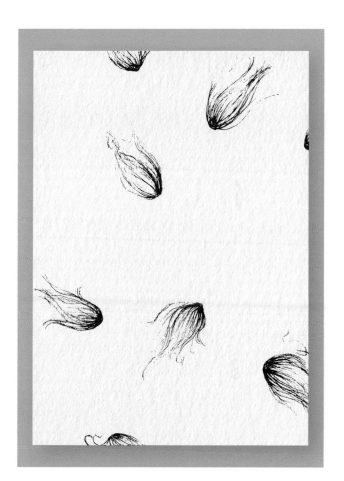

**6** Try to vary the direction of the forms as well as their distance from other forms. This will help give a sense of a naturally occurring pattern.

**7** Be purposeful in your placement—either position all forms within the confines of your page or purposefully run a few off the edge, as I have done here.

# Playing with Repetition and Variation: Coil Pattern

One of the connections between nature and art that I find most fascinating is a pattern called the Fibonacci sequence. It's a mathematical formula that describes a growth pattern commonly found in nature. You'll see this pattern in hurricanes, galaxies, the branching of trees and nautilus shells, for example. The Coil pattern was inspired by a nautilus shell. Of course, our coils probably won't follow this exact mathematical formula, and that's good. The imperfections and variations show that the drawing was made by hand, not a machine, and they are unique and beautiful.

Let's explore some of the ways in which we can use repetition and variation in our slow drawing patterns. This is one of the most enjoyable and satisfying ways to create better art. For example, in the Coil pattern, imagine how you can vary both the coil itself and how you present it on the page. What if you made the coils in varying sizes? What if you overlapped your coils or lined them up in a grid? What if you used different colored pens or drew a splash of color over them? Use each drawing as an opportunity to repeat what you have done before, but with small variations.

## Patterns in Nature

Look up "the Fibonacci sequence" to learn more about this fascinating connection between nature, art and science. As you look over the patterns that follow the Fibonacci sequence, identify 2 or 3 that speak to you the most. Create your own abstract pattern by simplifying the form a bit. That's what I've done with most of my slow drawing patterns, and I find the repetition of simpler forms meditative.

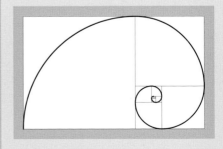

**1** Begin by drawing a spiral shape with roughly 2 revolutions, much like a nautilus shell.

**2** With your pen at the center point of the spiral, draw a curved line to the inside of the first turn of your spiral. This should create a little almond shape.

**3** Go back to the same center point and draw a few more curved lines next to the first. I can usually fit in about 3–6 lines starting from the center point, depending on the size of the coil.

**4** You may want to rotate your page slightly each time you draw a line, so the curved lines progress easily along the spiral. The coil should begin to look like a stripy snake wrapped in a coil.

5 Once you have completed the first turn, draw the curved lines from the start of the coil (the top of the snake's head) and then move on to the body, with each curved line reaching the inside edge of the spiral until you reach the end of the line. If any of the segments of the coil look too big, just add more lines to fill.

6 Now add more coils to the page. As you do this, pay close attention to what feels good to draw and what pleases your eye.

7 Make several different drawings, experimenting with variations in the size, orientation and position of the coils on the page.

If you wish to explore this drawing further, see page 108 for a creative variation.

# Focus on Going Slow: Bloom Pattern

When teaching, I always invite students who are new to slow drawing to focus on process over product. I advise them to draw slowly—as slowly as possible. I find this slow, mindful approach helps students progress more quickly because mindfulness keeps the inner critic at bay.

Give yourself permission to let go of the outcome for now. Bloom is an excellent pattern for practicing the slow part of slow drawing. It is formed from a series of raindrops (or petals). If you draw too fast, you'll cross over the line of the previous raindrop, creating a messier look. You might like this esthetic, and I encourage you to embrace it, but whatever your style, see what happens if you draw more slowly.

With this pattern, I observe my movements with curiosity: I watch the line for each raindrop extend down, curve, and gently climb back to the starting point. When I go slowly enough, I often don't cross over the line from the previous drop. A certain amount of imperfection gives the pattern a handmade quality that is beautiful, but I like to aim for a bloom which is neat with small imperfections. You can play with this idea and see what feels good to you.

## Slow Drawing Timer

If slowing down feels stressful at first, you might set a timer for 5, 10 or 15 minutes. Then, set a goal to draw as slowly as you can during that time, rather than trying to finish the Bloom pattern. How slowly and gently can you form each raindrop or petal? I frequently draw in this way and find it much more relaxing, as it puts the emphasis on process over product. You might experiment with slow drawing your blooms over several short sessions and see how that impacts your experience.

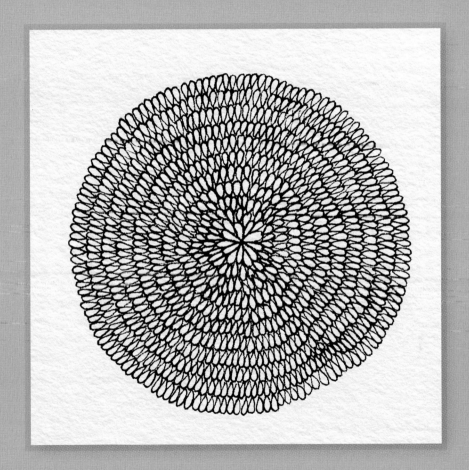

**1** Form a small raindrop shape on the page, with the point sitting in the center. This shape is your first petal.

**2** Turn the page slightly, and draw a second petal right next to the first, again with the point in the center. Repeat this process, moving the page in a circle, until you have a continuous ring of petal shapes.

**3** Nestle the points of the next set of petals into the spaces between the petals in the first row.

**4** When you run out of spaces between petals, begin a new row, this time touching the points of the petals to the tops of the petals in the previous row.

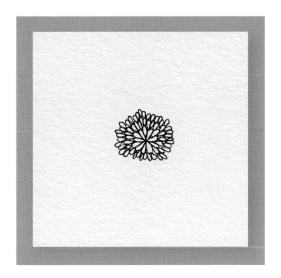

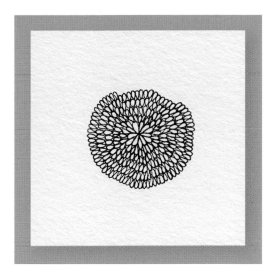

5 Continue drawing in this way, turning the page and nestling new petal shapes into place. Sometimes I have to draw petals slightly bigger or smaller to make the pattern work. These imperfections can be beautiful, and they happen in nature occasionally, too.

6 As you draw, your overall shape might be wonky and not round at times. That's okay. Hold the paper at a distance, and often you'll see that the drawing works as a whole.

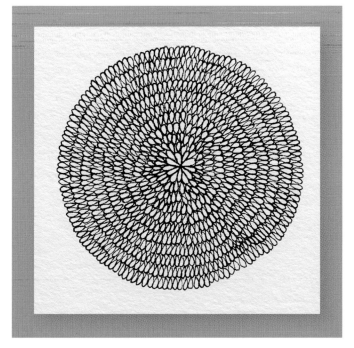

7 As the Bloom pattern reaches the size you'd like, begin to round out the shape, adding petals here and there, as needed.

# Procuring Patience: Dot Clouds Pattern

You can't make a Dot Clouds drawing quickly, as that just doesn't work. Dot Clouds is a pattern that teaches patience. Dots invite you to enjoy the simple act of touching the pen to the page.

Slow drawing is an active meditation. Feel your hand on the pen, notice the rhythm of the tip touching the page and watch the ink descend into the fibers of the paper. Notice that you are here in this moment, drawing, and appreciate it.

You may lose your way and begin rushing your drawing. You might notice that your hand feels tense, or that your page is full of comets instead of dots. That's okay. We all slip into this well-worn groove of "hurry up" that Western culture values. Here's something to ponder:

Rather than seeing how many dots you can draw in five minutes, why not notice how you draw dots for five minutes?

## Play, Rotate and Take a Step Back

**Play with the Density of Dots**
See what happens when some dots cluster in the bottom left or middle of the page, or in piles. Let some dots pile up and others spread out. When you move and draw slowly, you'll find that the dots seem to arrange themselves because the slow pace makes room for the imagination.

**Work on Three Pieces in Rotation**
When you aren't sure what comes next, don't make marks randomly out of frustration. Just move on to another drawing.
Keep rotating these as you draw, so your marks and patterns feel fresh.

**Hold at Arm's Length**
Since you are building patterns with the smallest possible mark, you won't see the big picture unless you hold the piece of paper or card at a distance. Do this frequently as you draw.

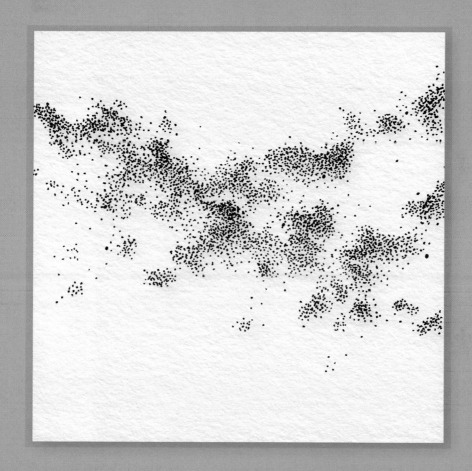

1 You may want to start as many as 3 Dot Clouds drawings at once to keep the pattern fresh and flowing. If you do this, start with 3 drawings placed side by side, make some dots on each, and keep rotating as feels right to you. Begin by making your first cluster of dots anywhere on the page.

2 Continue adding more dots to the cluster. Erasing the perfect white of the page can be a powerful first step to overcoming the fear of messing up.

3 Keep adding dots to the cluster to create a chaotic pattern, with some dots sitting very close and others farther away.

4 Allow the cluster to spread out a bit more—perhaps placing some dots farther off to the left and right. Watch as a "shape" begins to form from the cluster of dots.

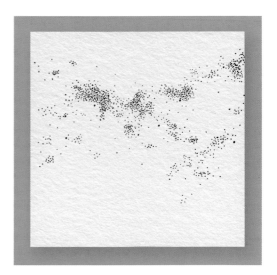

**5** Allow some dots to spread out farther away from the first cluster and others to make new clusters. This is a wonderful way to experience mindful drawing. You are watching the process unfold—almost as if you were not in control of it.

**6** Keep adding more dots and clusters. Try not to overthink the placement of the dots, but rather treat your first drawings as explorations of this technique.

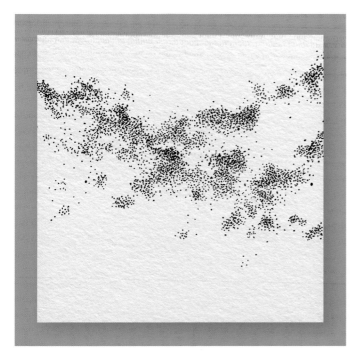

**7** Notice what the dot clouds remind you of—perhaps murmurations of birds, stars or cellular patterns. Try to resist the urge to make a recognizable object with the dot clouds—but instead see which abstract shapes and formations please you.

If you wish to explore this drawing further, see pages 48, 49, and 130 for creative variations.

Watercolor splash with circles.

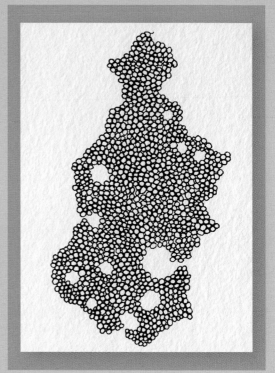

Circles clustered around negative spaces.

Collage of Exhale (page 58), Rice (page 118) and other patterns.

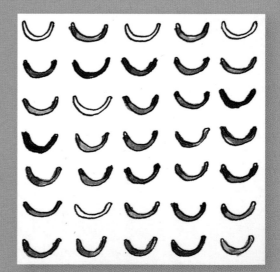

U-shapes in a grid with watercolor.

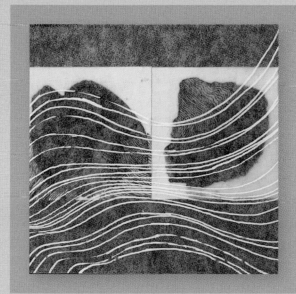

Edge (page 42) with watercolor and Wave (page 110) on tracing paper.

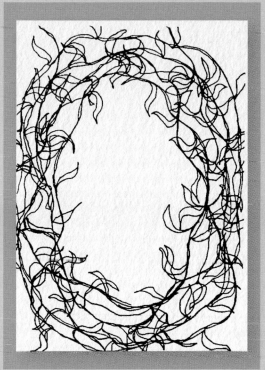

Wander (page 132) drawn in large, repeating ovals.

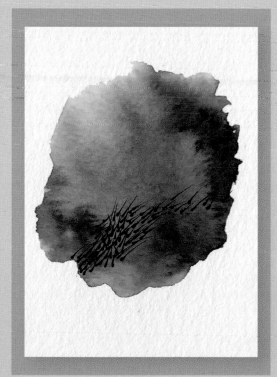

Watercolor splash with dot and flick marks.

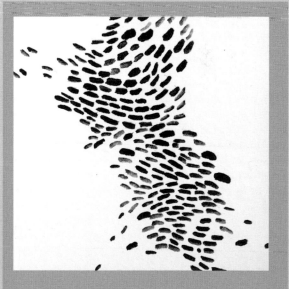

Brush marks collecting into shapes.

# Listening In: Fish Pattern

As you slow draw, you'll be practicing tuning in through the senses. With the Fish pattern, let's take an opportunity to tune in to what you can hear. To do this, I invite you to turn off any music, podcasts or other media. Any noises that are out of your control are part of the moment and part of what you'll be noticing.

Listening in slow drawing is all about curiosity. When I steady myself and draw slowly, the sound of the pen is barely perceptible. Ask yourself: "When can I hear myself drawing?" Experiment with drawing at different paces and in different ways. Engage your inner scientist and see what you discover.

What else can you hear as you draw? Your breath? Birds? Cars? Are there noises you find yourself pushing away, like loud horns or perhaps airplanes? What would happen if you accepted those noises rather than fighting them—invited them in even?

## Soften Into the Moment

There are no "right" or "wrong" sounds. Our practice is welcoming an awareness of what is happening while we are slow drawing. For me, softening into the moment is a powerful cue. This doesn't come easily to me—I'm a person who tends toward action when I feel uncomfortable. But mindfulness practice teaches me not to waste energy on unimportant details. I find this softness allows me to relax more in drawing, and in my life, making me feel more creative and alive.

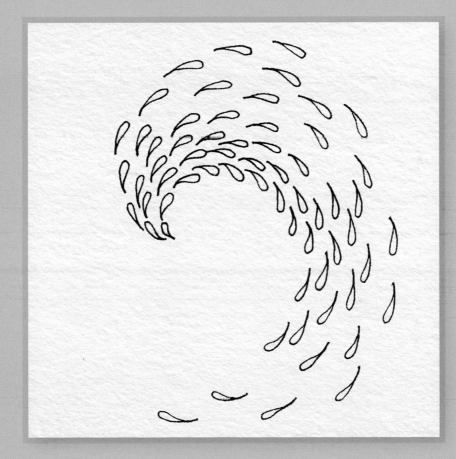

2 On your real pattern page, draw a curved fish, as you did in the previous step, slightly below and to the right of the center of the page. Now draw a second fish—next to, but just slightly ahead of the first— and a third ahead of the second.

1 First, make a shape that looks like a fish or droplet on a piece of practice paper. Begin by extending out at a diagonal, then curve round in a dome and return to your starting point. Either curve the fish, as I have here, or make it elongated and straight.

3 Continue in this way, adding a fourth and fifth fish while curving upward and round slightly to the right.

4 Now keep drawing more fish and bending them up and to the right, as if all the fish were forming a half-circle in the middle of the page.

**5** Now draw a second row of fish, staggering this slightly from the first row to avoid too many fish lining up next to each other. You want the arrangement to feel natural.

**6** Now draw more fish that extend outward and open up the curve. The overall pattern should now begin to resemble a wave.

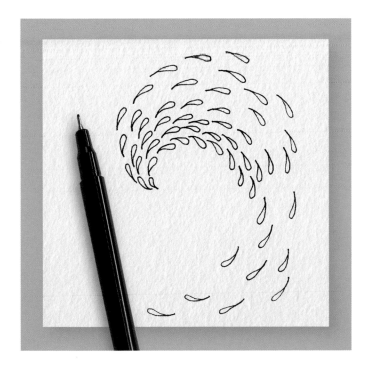

↺

**7** You may want to turn the page as you draw to help form the curve. I also find that turning the page helps me to see new perspectives and create better patterns. Hold the page away from you to see the big picture, then add fish in little clusters here and there as needed.

To explore this drawing further, see page 49 for a creative variation.

# You Deserve Creative Time: Cracked Pattern

Cracked is a pattern that takes time, which means you can take it slowly and watch your pattern emerge. For newer students, a dense and time-consuming pattern like Cracked can bring up anxiety. They worry it will take too long, don't give the pattern much thought, and draw too fast. Not surprisingly, they don't care for the result. They will say, "See? I knew I couldn't do it. I *am* wasting my time." And this whole series of thoughts—from the idea that it will take "too long," to the impulse to rush, to the harsh criticism of the result—is the work of the inner critic.

Slow drawing is not about filling the space or making the "perfect" drawing. Instead, it's about noticing and enjoying the process, imperfect as it may be. You picked up this book because the artist within you knows that spending time on your creativity makes you feel whole and grounded. I invite you to commit to short bursts of time spent slowly drawing, so you can feel more whole and grounded. You deserve it. You are worth the time it takes to do your best.

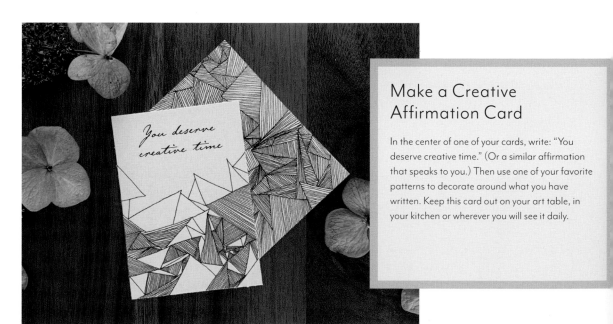

## Make a Creative Affirmation Card

In the center of one of your cards, write: "You deserve creative time." (Or a similar affirmation that speaks to you.) Then use one of your favorite patterns to decorate around what you have written. Keep this card out on your art table, in your kitchen or wherever you will see it daily.

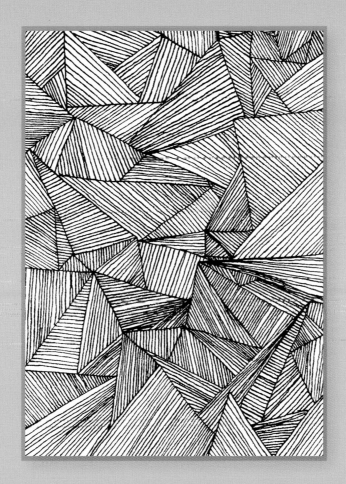

**1** Begin by drawing a triangle on the bottom of the page, using the edge of the paper as one of the sides. Add another triangle on either side of the first, allowing one of the triangles to overlap.

**2** Next, fill in the triangles by drawing parallel lines close together. Sometimes I like to play with how close I can draw the lines without touching. You can vary the direction from one triangle to the other.

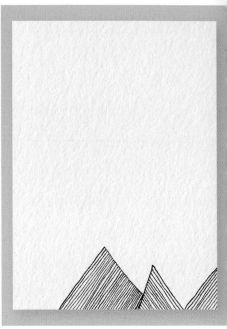

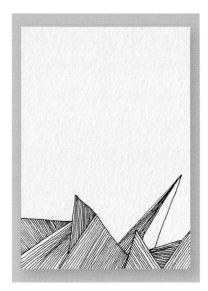

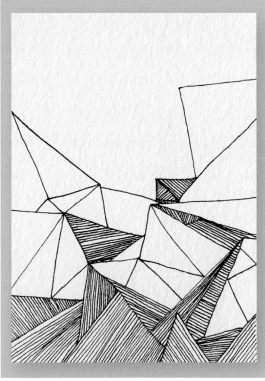

**4** Draw more triangles, but focus on variation, making some tall and thin, some very tiny, and others fat and squat.

**3** Remember to go slow and take your time; there will be a consistency to the drawing that looks purposeful and therefore artful, whether it has wobbly lines or not.

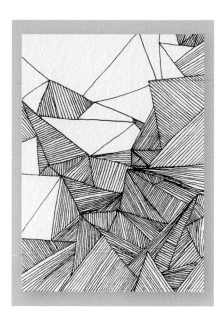

**5** Continue dividing your page with triangles, sprinkling in a few 4-sided shapes for variety.

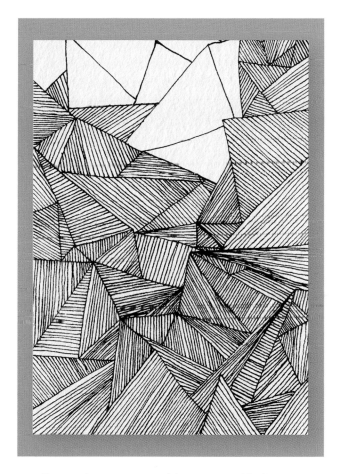

**6** While filling in your shapes, you can play with the effects of density—what does it look like to have a very densely packed triangle, or a sparser one?

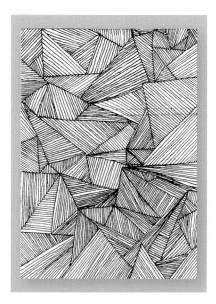

**7** If you wish, experiment with leaving some blank space on the page, or blank spaces inside some of the shapes. This is a fun variation.

# Drawing Inspiration from Nature: Lichen Pattern

Lichen is one of nature's creations that inspires me the most. My family camps in Maine each year, and we go to a special place to stare into tidal pools, climb over rocks and photograph the wild landscape. We love the bright orange lichen that glows like a constellation against the gray rocks. Visually the lichen is magnificent, but look closer and it has a quiet, intimate beauty and is made of chalice-like cups. I hope this book inspires you to slow down and look more deeply at nature and appreciate the beauty all around us, whether in the ocean or woods, or on the drawing page.

## Go On a Lichen Treasure Hunt

The next time you go outside, take your phone and go on a lichen treasure hunt. Look on stones, trees, soil and buildings. Take photos of the different types of lichen and see how many you can find. Some are relatively flat while others have wavy, crusty edges, and still others look more like branching moss. Once you begin looking for lichen, it's hard to stop seeing it—it's everywhere!

Now have a go at the lichen drawing described over the following pages. Then, look at your lichen photos and study them. Observe the overall shapes and details. See what speaks to you. Take out a sheet of paper and begin making some exploratory drawings of what you see. Feel free to simplify shapes and play with developing your own Lichen pattern.

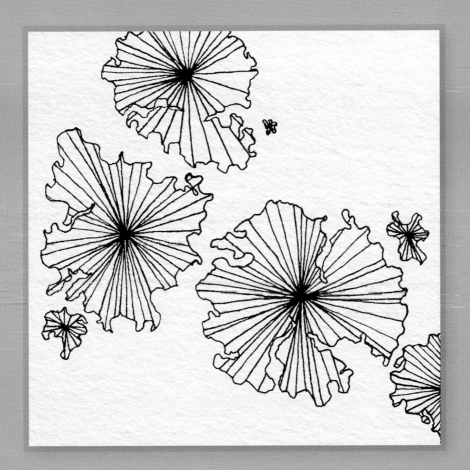

**2** As you draw the outline of the "island", notice that the edge wanders up and down to form scalloped edges. It's a fun and forgiving shape.

**1** Think of the overall shape of the lichen as a round-ish island viewed from above. Pick a point in the top left of a square piece of paper, then let your line wiggle and meander, turning in and out, up and down.

**3** Next, create an inlet. To do this, allow the line to meander a little toward the top of the page, then make your way back down again toward the center of the page. You can do this once, or up to 4 or 5 times if you want more than one inlet.

**4** Continue letting the line bump up and down to create the shape of the island, adding inlets when it feels right, until you reach the starting point once more.

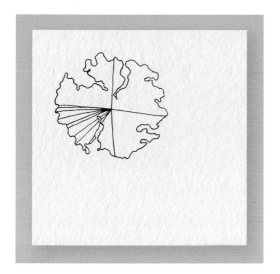

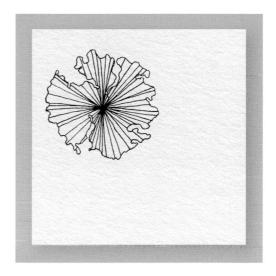

**5** Now find the point that is roughly in the center of the shape and make a tiny dot. Draw a line from the center point of the shape to the outside edge. Do this 3 more times to create 4 quadrants inside the lichen.

**6** Now fill in the quadrants with lines. You'll see that you have created a sort of burst, suggesting the attachment point of the lichen.

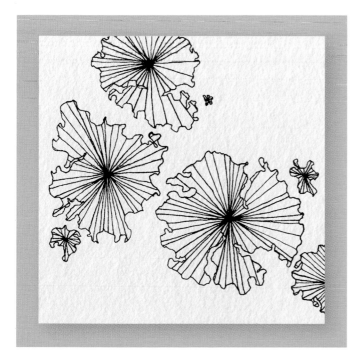

**7** You can draw just one lichen per page, or play with adding a few in a variety of sizes, as I have here.

To explore this drawing further, see page 49 for a creative variation.

# Connection and Disconnection: Cells Pattern

There is a feeling of closeness in the Cells pattern—the Cells seem to cozy up to each other. Sometimes as I draw the cells, it makes me consider my feelings about closeness and community. There are communities where I feel so in my element that I want to give each person a bear hug. But even there I need a certain amount of space to do my own thing.

## Varying Your Patterns

One of the really magical aspects of slow drawing abstract patterns is the space it leaves for variation and experimentation. My hope is that you use what I offer as a starting point, and then draw each pattern in a variety of ways, discovering what feels good to you. A circle with an oval in the center for the Cells pattern is simple to draw and also invites endless variations for patterning. Here's a few ideas to get you started: Overlap cells, line cells up in a grid, create a cluster of cells in the top right-hand corner of the page, or make some large cells and some small ones.

As you explore the Cells pattern, you might also want to think about your relationship with the communities to which you belong. Is there a community where you feel comfortable being close to others? Which community makes you feel as if you need your space? There's no right or wrong answer, but rather an opportunity to reflect on what makes you feel nurtured. As you play with this idea, you might allow these reflections to influence how your cells cluster on the page.

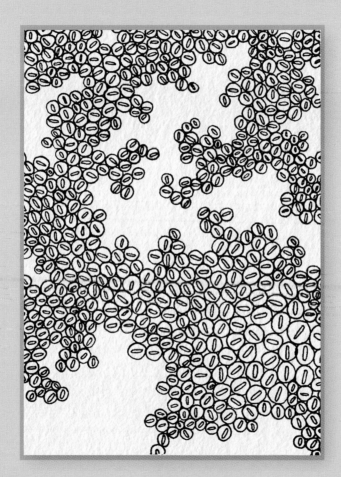

 Draw a small circle
on the right side of
your page.

2 Next, draw an
oval in the center
of the circle—this is
your first cell.

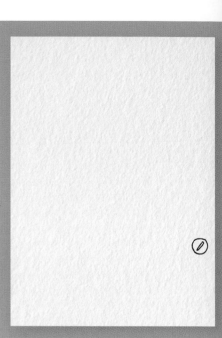

4 Continue
adding cells,
remembering to
draw slowly and
noticing through
your senses.
Drawing highly
repetitive patterns
such as cells
offers amazing
opportunities to
relax deeply into
the moment.

3 Now draw another cell adjacent
to the first, making sure that the
sides are touching. Keep adding cells
in the same way, allowing a cluster
to form.

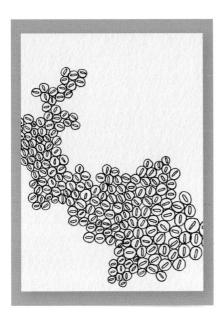

5 As your cells near the sides of the page, run them off the edge to give the impression that the pattern continues beyond what you can see.

6 Pay attention to the overall shape of your cluster—hold your page at arm's length periodically and turn it frequently as you draw. The work will change as you view it from different vantage points. Trust your instincts for where to add the next cells or when the drawing feels done.

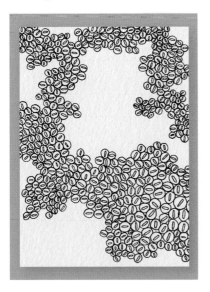

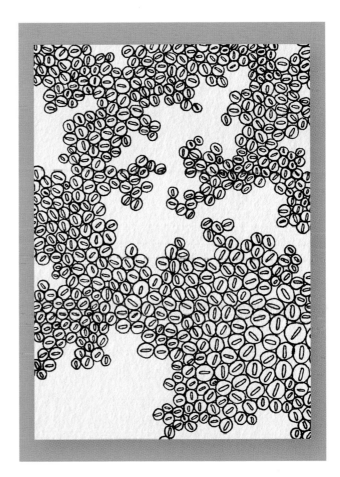

7 Create several drawings with the same pattern to develop your ideas further. You'll find that your work is much richer when you give it time and space to develop.

# Looking Deeply at Nature: Kelp Pattern

One of the practices that gives me the most solace is walking alone in nature. I slow down, deeply absorbing the details I normally can't and feeling the wind on my skin as I stop to study the patterns in each leaf, lichen or shell. A quiet comes over me, a unity with the earth and myself. I pause for long periods, studying the branching and texture of a lichen or the constellation of worm holes in a clam shell. Mindfulness meditation is about having a singular focus. Nature gives us endless opportunities for mindfulness. Through slow drawing, you acquire skills in art, but also in mindfulness.

You don't need to take a trip to the beach or redwood forests to be fascinated by nature; just step outside your door. Even in a city, there are opportunities to study the lines in a blade of grass, the color and shape of lichen sprawling across a stone wall, and the iridescent sparkle of beetle wings. Seeking out nature's beauty is grounding and deepens your connection to your drawing practice.

## Deepen Your Connection to Kelp

The Kelp pattern is derived from a very beautiful algae called colander kelp. This pattern has sloping curves and sharp points along the edge and an array of holes on the inside. Do a little research on this kelp. What purpose do the holes serve? Where does kelp typically thrive? Study photos of it with curiosity, taking note of the holes. What shape are they? Do they remind you of anything? Study the outside edges of the kelp as well, noting the dips, curves and points. These can inform your drawing. Once you feel ready to draw, I invite you to put your research away. Draw the Kelp pattern with your investigations floating around in your imagination, and see where this leads you.

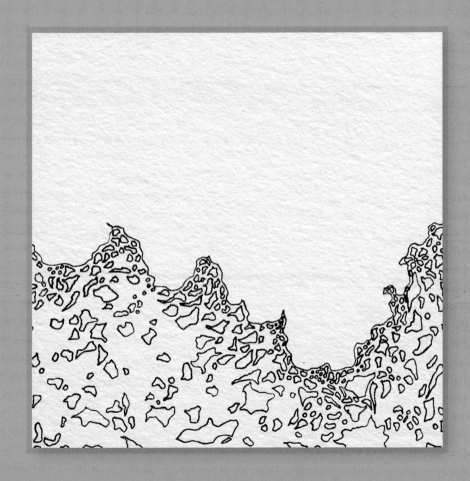

1 Start at the left side of the page, about midway down. Slowly start drawing a meandering line that moves up and down across the page, as if it were traversing hills and valleys.

2 Be sure to create a mixture of rounded and sharp edges as you draw the line.

3 Allow one or more valleys to dip down quite low and another to sit above the midline of the page. This creates an interesting edge for your Kelp pattern.

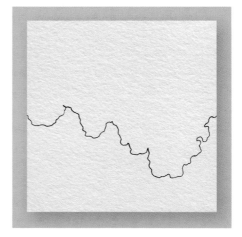

4 Keep drawing the up-and-down line marking the edge of the Kelp pattern until you reach the other side of the page.

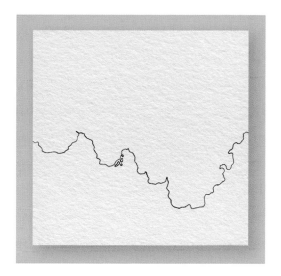

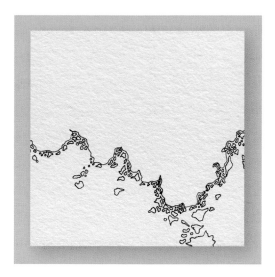

5 Begin drawing some small holes in the kelp, close to the edge. You can vary the shapes and sizes of the holes, as I've done here, or keep them more uniform.

6 Draw clusters of holes farther into the body of the kelp. Keep the holes as tightly packed together or sparse as feels right to you.

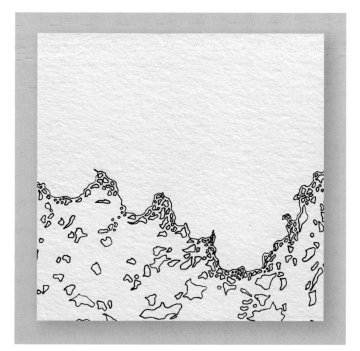

7 Hold your drawing at arm's length and squint your eyes to see whether you need to add more holes.

If you wish to explore this drawing further, see pages 48 and 109 for creative variations.

# What Feels Good to Draw?
# Squiggle Pattern

For the Squiggle pattern, I'm inviting you to use the drawing as a tool rather than to copy my approach. Your goal is not to make a beautiful drawing, but to discover patterns of movement that soothe you. As you draw, ask yourself: What movements feel good?

You can gently pay attention to your fingers, arms, core and breath as you draw. Go slow. The more you slow down, the easier it is to notice. Play with different ways of squiggling to see how this changes your experience and to discover what you enjoy. Once you find something that feels good, stick with it for a while.

## Dancing Between Process and Product

Explore this pattern numerous times, in various drawings. Once you develop the practice of drawing for relaxation, sit back and look from a distance at your drawings to see what has appeared on the page. You might turn them around as well. Once you have identified at least one shape or pattern you like in these drawings, you can experiment with these. You can dance back and forth between prioritizing movements that feel good and movements that make beautiful lines. These open explorations will help teach you to relax into the drawing process, find unique patterns and keep the inner critic at bay, which will enable you to create.

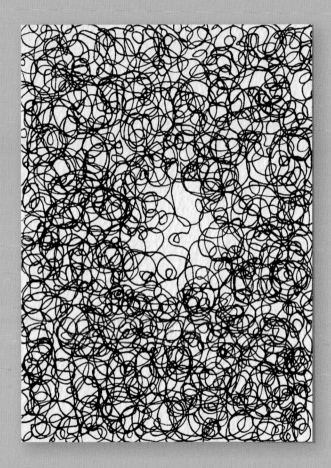

**1** Draw a continuous, squiggly line that twists and loops, starting at the edge of one corner of the page.

**2** Get curious about the following question: Which movements *feel* good as you draw your squiggly line?

**3** You might experiment with looser lines, tighter lines, loopier lines, overlapping lines, circular lines and sharper lines.

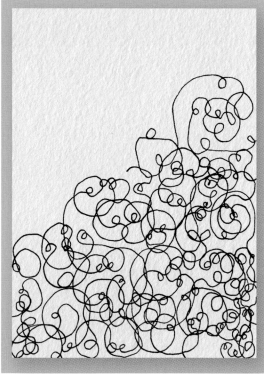

**4** Keep asking yourself about new ways you could move through the space and observe how each change feels. Once you find something that feels good, keep repeating this as long as it feels right. That might mean creating just 1 drawing or 15.

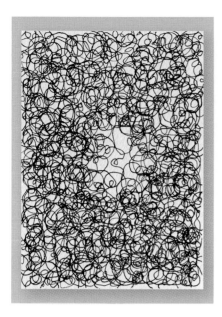

**5** When you feel that you've found one or more ways of squiggling which feel relaxing, you can begin dancing between a focus on drawing what feels good and what looks good. Explore drawing what feels good, but then periodically hold your drawing at arm's length, assess what it needs, make adjustments as required, and then shift back to drawing what feels good.

**6** A fun variation is to play with density, allowing the squiggles to overlap. Or write a message in some of the negative space between the lines.

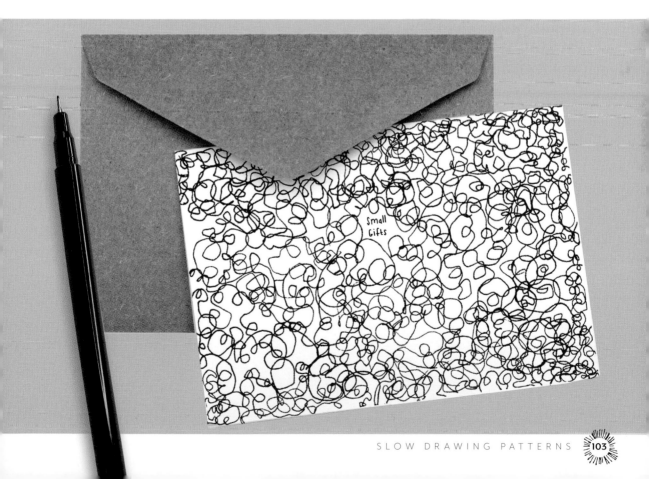

# Making Space for the Imagination: Flock Pattern

Several years ago, I made a painting using burnt sienna and black—like deep, rich earth. I used a paint marker to layer white "X" shapes on top and they seemed to pop off the page—like little birds. I was fascinated to see that a tiny mark could convey so much.

Around the same time, I began noticing bird murmurations—hundreds of starlings, moving in concert in the sky. They swooped and spread, collected and transformed, like a shape-shifting bird ballet. If you've never witnessed a murmuration, seek out a video, as I believe it will add delight and wonder to your Flock pattern explorations.

A group of little "X" shapes, depending on how you render them, can look like a murmuration of birds. I love how this opens doors to the different ways in which we can make art and show the links between art and nature. It's just one of the connections that drives my never-ending curiosity about nature-based patterns. I hope that it sparks some of the same curiosity in you.

## Following the Narrative

As you draw quietly, you might notice that your imagination begins to create a narrative about the birds. Allow this to influence what you draw. Notice how some birds cluster together, while others strike out on their own. Even though you are the artist, you can pretend that you are following instructions from the birds about where and how they want to be on the page. This is a fun way to engage the imagination and take the pattern further.

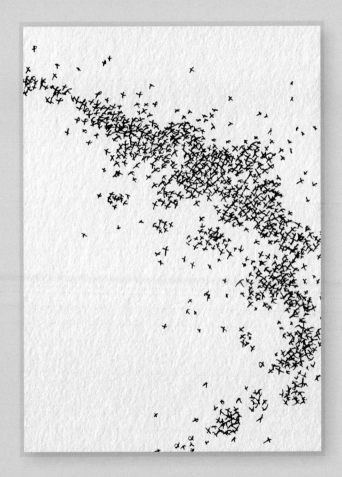

1 For this exercise, use 2–4 pages and rotate between them, so you have plenty of room to experiment. For simplicity, I'll just show one page from my sample. Begin by drawing a cluster of tiny "X" shapes (these represent birds).

2 Next, draw a few birds lingering outside the initial cluster—notice how a formation is beginning to take shape.

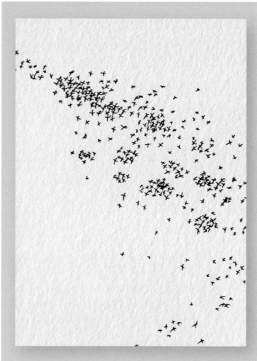

4 If you notice a grid-like pattern beginning to form, break it up by overlapping some of the birds and drawing others at a distance. This will give the flock a more natural and realistic feel.

3 Imagine all the birds in motion—clustering and spreading, lifting and falling—and let your marks reflect this.

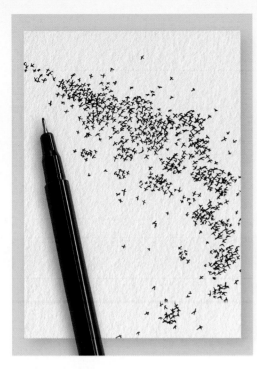

**5** Experiment with the way you form your birds. How does a bigger or smaller "X" shape affect the look of the bird? What about a messy versus a neat bird? Every so often, hold your drawing at arm's length and squint. This will help you see the big picture and determine your next steps.

**6** Whenever you feel unsure about what should come next, rotate to a new drawing.

To explore this drawing further, see page 131 for a creative variation.

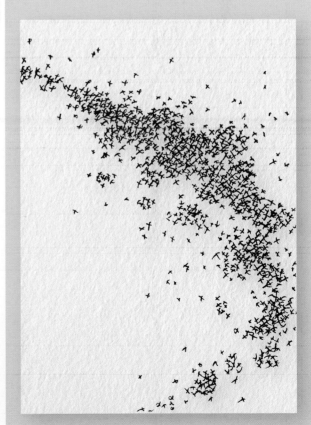

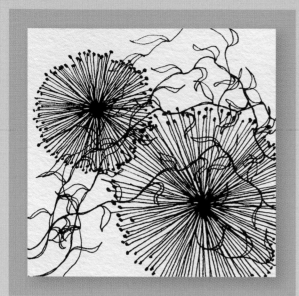

Interwoven Exhale (page 58) and Wander (page 132) patterns.

Connected triangles and layers of paint.

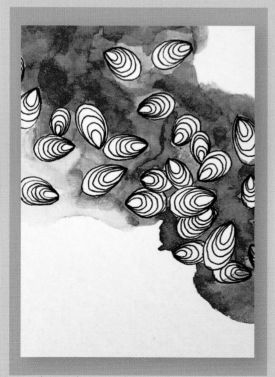

Mussel (page 114) surrounded by watercolor paint.

Connected triangles with Coil (page 66) variation.

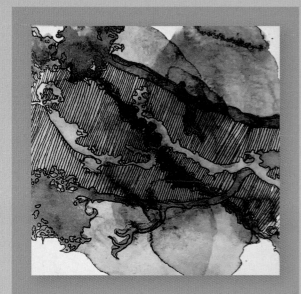

Kelp (page 96) drawings, lines and watercolor wash.

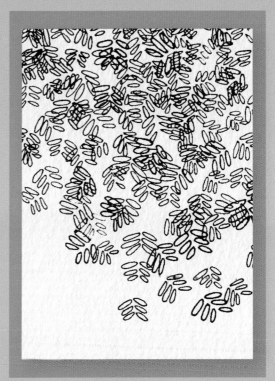

Ovals clustered in sets of six.

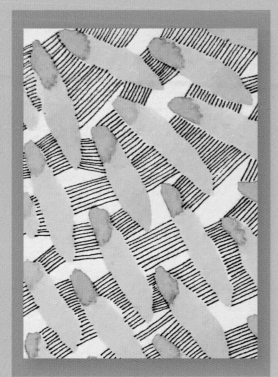

Watercolor strokes connected by straight lines.

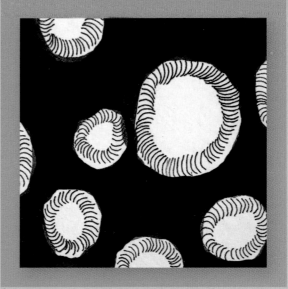

C-shapes collected into circle shapes and surrounded by ink.

# Let Your Hand Surf the Ocean: Wave Pattern

Wave is a soothing pattern. You set up a structure, and then your hand echoes the rise and fall of the waves. For those of us who have a deep connection and affinity with the ocean, this motion can feel familiar and calming.

I invite you to let your hand surf the wave on the page. As you draw, you may notice that your hand tends to insert little waves and wobbles of its own. What would happen if you let go of control? Let the Wave drawing emerge with your help, not your domination. Rather than trying to fight the extra waves, why not see what happens when you embrace and echo them?

As you deepen your relationship with the Wave pattern, you might get curious about what it has to teach you. Perhaps it speaks to you on a metaphorical level—stimulating you to consider how you are managing the ups and downs in your life. Or it might inspire you to observe how close you can draw lines without them touching. There's no right or wrong, but rather a practice of inviting a playful curiosity into the slow drawing process.

## Get Curious: How Slow Drawing Impacts Your Life

Now I've been slow drawing and slow wandering in nature for a few years, I've found that as soon as I begin creating or wandering, my senses are heightened, I slow down, and my body gets into a relaxed, observant state. While I can't say that I've been able to master my own impatience, crankiness or reactiveness, I can see a big difference in my ability to observe myself and others with more curiosity, and I react the way I'd like to a bit more often.

I also see a huge difference in my ability to have patience in my art practice. I take my time more, put more care into the work, and feel more confident in my ability to do hard things. This might sound rather like perfectionism, but it's different. It's about believing in myself, and also believing that I am worth the time and the materials it takes to create something I find satisfying. It's about taking the time to be present and enjoy the process of creating, rather than hurrying myself along in order to finish, to be productive, to make something of "value." What's of value is the process of making, and the adventures it offers me. If you'd like to, I invite you to set a timer for 5 minutes and journal about what you notice with your slow drawing practice and the impact it has had so far.

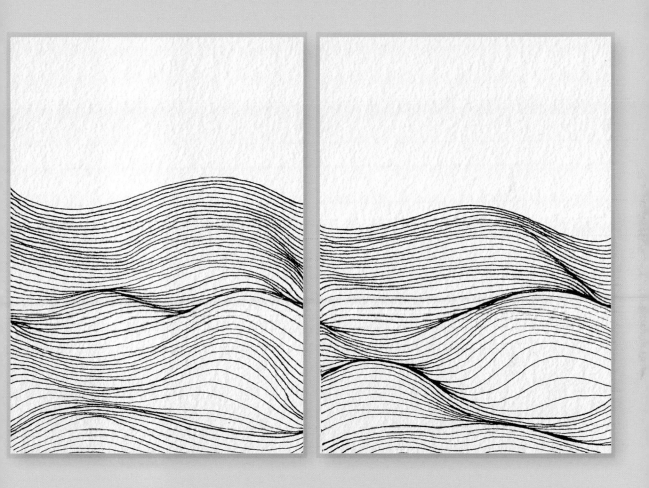

1 Create a basic structure by drawing 3 wavy lines on the page. Start by drawing a long wavy line that gently goes down, then up, and down again, about a third of the way down the page.

2 Next, draw a second wave that goes down and up, and then down again in the bottom third of the page.

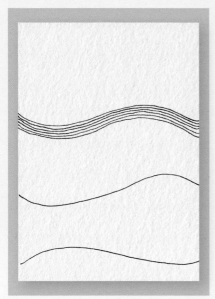

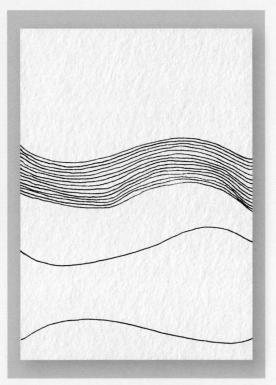

3 Below the second wave, draw a line that curves up, down, and then up again. I sometimes let this third wave touch the second. Now that you have a basic structure of 3 waves, begin filling in the lines that define each one. I like to start at the top, drawing lines close together that echo the first wave.

4 Keep drawing more undulating lines to fill in the first wave. Don't worry if the lines wobble slightly and sometimes nearly touch each other.

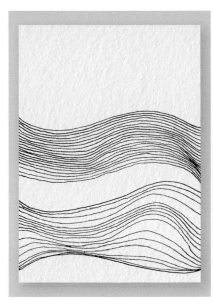

**5** Then fill in some of the lines above the second wave in the same way. Around this time, I find it helpful to hold the drawing at arm's length to get a sense of the big picture. I then add more lines below the first and above the second wave, as I see fit. Next, fill in lines between the second and third waves. You can play with what effects you get when you keep lines close together and when you space them farther apart.

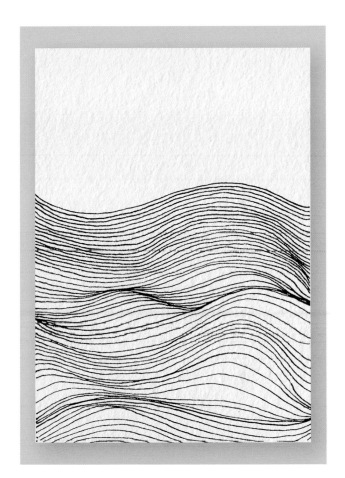

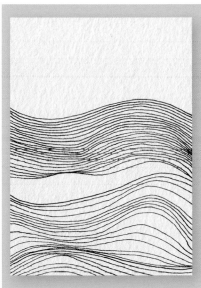

**6** As you can see, I've allowed the wave to get more open and loose at the bottom, by spacing out my lines and making a taller arc in the lines. At this stage, you can also fill in the lines below the third wave you drew in step 3.

**7** In this drawing, I felt that the space between the first and second waves looked a bit mouth-like, so I added more lines. You can always make adjustments such as this at the end—hold the drawing at arm's length to get a clearer perspective on what it needs.

If you wish to explore this drawing further, see pages 49 and 79 for creative variations.

# The Comfort of Round, Repetitive Forms: Mussel Pattern

After slow drawing with various groups of people over the last two years, I've noticed there are certain types of patterns that seem almost universally soothing. Mussel is one of those patterns, and I think it's because of the round, repetitive shapes.

## Give Yourself Grace

You may be thinking after drawing this pattern (or other patterns in the book): "I've tried this pattern 8 times, and I don't find it soothing at all!" That's completely okay. There's often a tendency to take advice from a book like this and measure ourselves against it. See how quickly our self-judgment rises up? These are the patterns that spoke to me. You are a different, amazing person with your own unique body and experiences which also deserve to be honored.

Make space for your wisdom in this process. When any pattern doesn't speak to you initially, if it feels okay, treat it as an exploration, making little changes in the approach each time you draw it to see where you find comfort and pleasure. But if there's something about it that strikes you as wrong, just let it go. You are doing slow drawing right when you push beyond your comfort zone slightly while tailoring the practice in a way that brings you relaxation and pleasure.

I think there's something about rounded shapes that feels soothing to most of us. The circle is a ubiquitous shape in nature; it appears in our bodies, in trees, fruits, plants, the planets and beyond. It's no surprise that the circle (mandala) appears in art from cultures throughout the world. In round shapes, there are no sharp edges—just a smooth line that turns inward. It makes us feel encircled and embraced, mothered and nurtured.

The other element that makes Mussel especially soothing is that each mussel-shell shape is so repetitive. Repetition gives us an opportunity to get into a rhythm, to develop a singular focus. This is often a component of active meditation practices. Think of chanting, yoga, knitting and walking meditations. Almost anything we do while tuning in to the moment can be a mindfulness meditation—but repetitive motion narrows the number of stimuli that we have to notice at once.

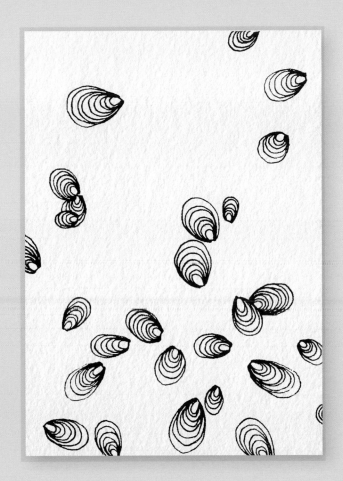

1 Start by drawing a tiny U-shape somewhere on the page.

2 Now echo that shape inside the first a couple of times, starting and ending at the same point, but leaving some space between the lines. The result should look like a drooping bull-nose ring.

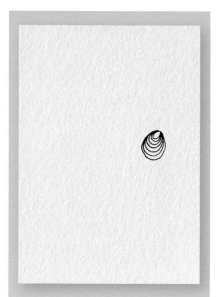

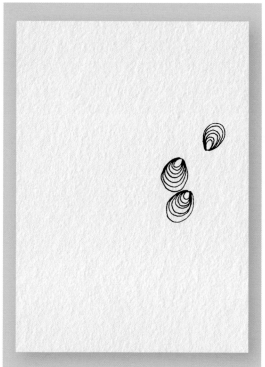

3 Repeat this process several times, echoing the U-shape and elongating the bottom of the shape so it begins to look more oval, like a mussel shell. Don't worry if your shell turns to the left or right; this happens in nature as well. Close off the end of the U-shape with a small line.

4 Now begin adding more shells. Focus on drawing slowly and enjoying the back-and-forth rhythm when you create the repetitive U-shape.

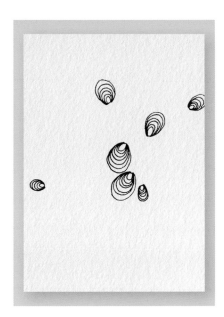

**5** When you feel ready to focus a bit on pattern as well, begin varying the size of the mussel shells slightly. You can also vary the proximity of the shells, with some overlapping and others far apart. This will suggest a collection of shells washed up on the seashore.

**6** Pay some attention to the shapes you create in the spaces between the mussel shells, as these can be interesting as well.

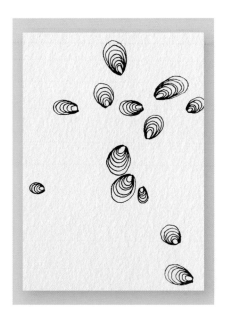

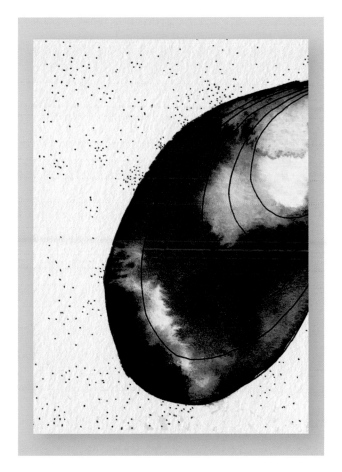

**7** To vary this pattern: Experiment with drawing one giant mussel shell on the page. Allow yourself to draw really slowly and enjoy the movement of the pen, back and forth. You could also add some loosely applied watercolor paint to the inside of the large mussel shell or around the smaller shells.

# Getting in the Zone: Rice Pattern

Of all the patterns I've created, Rice is one of the most popular. Like Mussel, it is a relatively simple, rounded shape that is drawn repetitively. This means your mind can relax a bit more as you draw. When people first see it, however, they sometimes feel overwhelmed looking at the large number of tiny marks filling the space. Don't be fooled by this pattern, though. Rice is about savoring: deliciously exploring the process of drawing a tiny oval. The Rice pattern evolves in stages, not all at once, although if you get into the zone, you might look up to realize a full hour has slipped by.

When drawing this pattern, I invite you not to focus on filling the space, but rather on the process of feeling the pen, watching the ink appear and getting curious about the way the shapes seem to turn this way and that. I like to imagine that I've accidentally dumped rice onto the countertop, and then draw the shapes as they lie there—some lined up and some at odd angles with one another. There's something playful for me about imagining how they lie there naturally.

I love slowly drawing something tiny and simple, and seeing how it multiplies to create a vast, textured surface, much like it does in the natural world.

## Play with Rice Shapes

How many different varieties of rice can you name? 5? 6? I could name perhaps 10, but I know there are a lot more and I got curious to find out how many. Unbelievably, there are not 10, 20 or even 200 varieties, but 400,000! That's a lot of different rice shapes. Some are squat, others elongated, some pointy and others round. Rice patterns can be similarly varied. You can play with the basic elongated oval shape I've created first, and then explore different oval forms to see what kind of rice your hand most enjoys making.

It's worth noting too that when you look at a rice grain under a microscope, it's not uniform. There are cut-off edges, bumps and pointy protrusions. Remember this when your inner critic says your ovals don't look rice-like enough. Your wonky rice shapes are just right. Mindful art is about learning to dance between making your best effort to improve your skills, listening to your body and imagination, and nonjudgmentally observing what appears. Over time, you'll discover immense beauty in your "imperfections" and the way the consistency of your hand makes an art of them.

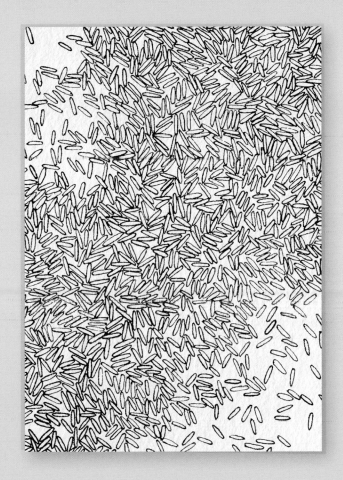

1 Begin by drawing a series of small, slender ovals somewhere on the page. I like to start in one corner and play with the different ways the ovals group together. I imagine I'm looking at uncooked rice spilled on the countertop.

2 Take your time and enjoy the motion of slowly drawing. A small oval is both simple and complex to draw. When you draw the Rice pattern, pay special attention to the second corner, as it can be surprisingly tricky to create a neat, rounded edge.

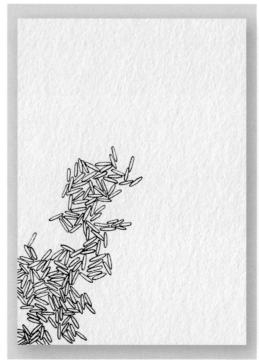

4 You can dance between practicing making beautifully rounded ovals and embracing the beauty of imperfections. Flat and sharp edges show the work of your human hand. You'll notice that because the marks are small and there are so many of them, the pattern is cohesive and impactful, even with little inconsistencies and imperfections.

3 Rice provides an opportunity to play with observing as you draw, rather than judging as you draw. As you approach the second corner of the oval, slow down and play with different ways of closing the shape. Does it help to let out a breath or to start from the opposite side of the oval? What if you make the curve slightly longer than you'd planned?

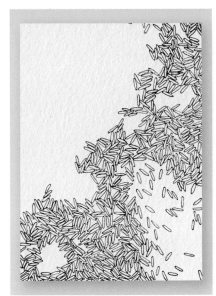

5 Turn the page as you go, to make it easier to draw the rice grains in different sections. I like to vary the direction of the grains and the way they come together. Some line up like a stack of books, while others run their rounded edge into the broad side of another grain. Some stay close and others stay distant.

6 You may decide to fill the whole page, most of it or just part. To see the big picture with this little shape, I stand back a lot. It's fun to change the overall design by adding rice grains in thick groups or sprinkling them into the open spaces.

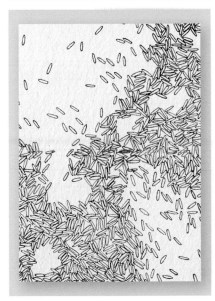

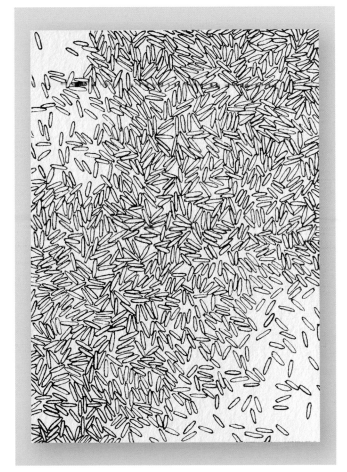

# Find What Piques Your Interest: Beneath Pattern

The Beneath pattern comes from playful, primal forms. Animals, plants, humans, tools and planets create a wonky, almost narrative-like pattern. I found the source for this pattern in a most unlikely place—the underside of a woodland mushroom.

## Go on a Slow Nature Walk

Beneath is one of my favorite patterns. So far, I have explored it in pen, watercolor and paper-cutting and yet I still have more to discover. Beneath makes it clear that slow drawing is not about mastering any particular pattern, but about slowing down enough to hear the imagination and developing a practice of noticing what lights your creative fire. That's the magic of a creative practice grounded in nature—it's both exhilarating and grounding.

Give yourself permission to extend your creative practice to the outdoors. Spend a minimum of 10 minutes in a natural space and look closely for patterns. Look at the holes and lines in shells and leaves. Study the texture and shape of bark, seedpods and stones. Remember to go very, very slowly and expect to find beauty in the small details—you may be amazed at what you see.

At the beginning of the Covid 19 pandemic, I started a practice of walking slowly in nature. I needed to escape my own four walls, but also to feel grounded and connected to something larger than myself in a time when I felt lonely and scared. Now, as I step into the forest and as the sounds of the birds and bugs grow louder, it's as though the vines, leaves and lichens wrap their arms around me, closing out the rest of the world. My breathing slows; my senses heighten. The rabbit and I regard each other and the brook speaks to me of the frost that is soon to arrive. I feel intimately connected. Nature's patterns present themselves everywhere I look.

On an early forest walk, I noticed some mushrooms growing on a dead tree. Unlike many mushrooms, they didn't have gills on the underside, but velvety "teeth" with irregular shapes instead. I gently plucked one and took a photo—I think it may have been a turkey tail mushroom. At home I was curious to see the mushroom more closely, and so I enlarged it on my computer screen. There appeared the warriors, buffalo, suns and swords of ancient stories, depicted on the underside of a mushroom. How deep the connections among nature's forms are.

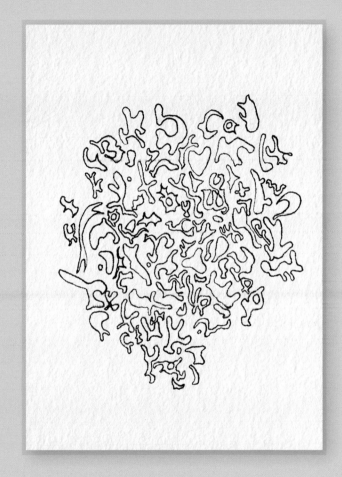

1 To recreate my pattern, draw an abstract shape near the center of the page. You could also find your own mushroom with a wild pattern on the underside or just use your imagination for the shape.

2 My first shape looked part human, part animal. I then added more shapes: a wild-looking sword, an abstract animal on all fours and a giraffe-like animal head.

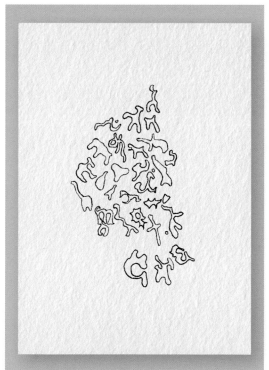

3 Next, experiment with drawing some other wild shapes close by—use your imagination and be inventive.

4 When drawing this pattern, I like to explore not only animals, plants and people in the shapes, but also letters—many of the shapes in the bottom of my mushroom resembled Ys, Us and Ts. You can add some of those too, if you wish.

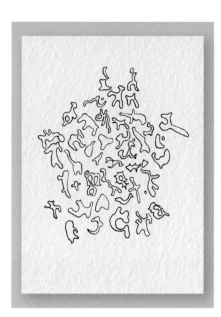

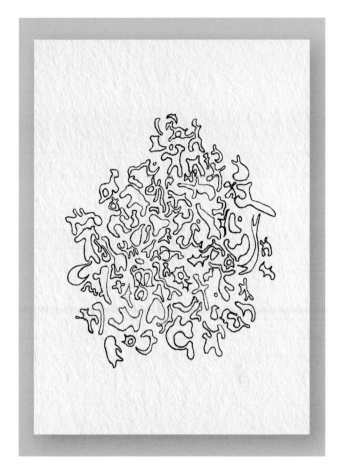

5 Experiment with a variety of rounded and sharp edges, squat and elongated shapes, and larger and smaller shapes.

6 As with many patterns, it's fun to play with the overall outline of the group of shapes on the page and also with how dense or sparse the shapes are. I love to pack the Beneath pattern densely, as it's fun to see what little wonders I can hide within it.

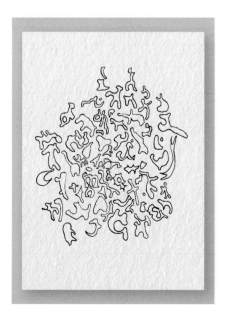

7 Beneath is one of the most playful patterns in the book, so give your shapes permission to have a bit of fun—let them frolic and cause mischief on the page.

# Weaving in Ink: Cloth Pattern

Drawing this delicate, tactile pattern is like creating a piece of cloth from ancient Mesoamerica. It's like weaving in ink and feels elemental and grounding. In weaving, the vertical lines are called the warp and the horizontal lines are called the weft.

When drawing the Cloth pattern, as I near the end of the warp and weft lines, I like to think about the way the thread might behave when loose. The ends would curl and twist and trail off into a wisp. Cloth unites order and chaos—the order of the grid and the chaos of threads breaking away. The push and pull of the slow drawing process is the same: we practice slow drawing to develop our drawing skills, while softening to allow for the beauty of imperfection.

With Cloth, above all I invite you to take your time. Enjoy the feeling of slowly drawing lines that wander along the length and width of the page. Notice what it feels like to build something, thread by thread. Notice how you can feel the pen cross over the lines you've already drawn, creating miniature rectangles and squares. The beauty of this pattern lies in the pleasure of slowly watching lines appear on the page and the cloth emerge. Like sipping fine liquor, the process is meant to be savored.

## Varying the Cloth Pattern

As you explore Cloth, it can be fun to play with different ways of rendering it. Try some variations: cloths with an open and airy grid of strings and others with a tight, close weave. I love the natural feel when some areas are tight, while others are loose. The size of your pen nib will also have a big impact on the drawing. Try using different sizes—I find an 003 or 005 easily make thin, wispy strings.

Finally, pay attention to where your "mistakes" take you. For example, see what happens if you repeat a line that veered off course. Play on a few scratch sheets, figure out the way things work and then use that information to embark on your first Cloth piece.

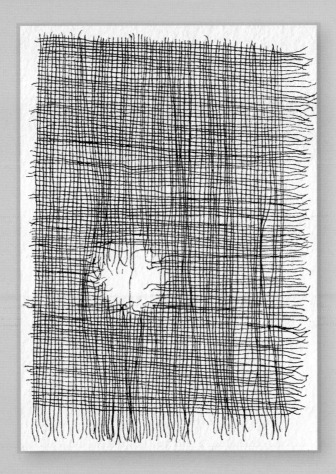

1 Draw a series of warp (vertical) lines close together. See how close you can draw the lines without them touching.

2 Bend some of the lines slightly at the start and end and make others shorter and relatively straight. You'll notice that both your hand and the texture of the paper will add some extra wobbles and waves in the lines. This will give the pattern a lovely sense of movement.

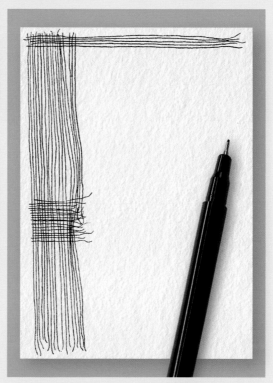

3 Once you've drawn several warp lines, begin adding some of the weft (horizontal) lines at the top as well. This will help you start to get a feel for the structure of the fabric.

4 Next, pick a spot where you'd like to create a hole—here, it's near the middle of the fabric. At this point, draw several weft lines that break off and fray.

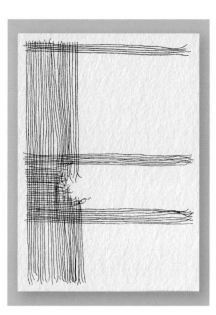

5 Next add some broken warp lines from above and below the hole. When you feel that the hole is the right height and width, begin drawing in the unbroken weft lines above and below the hole.

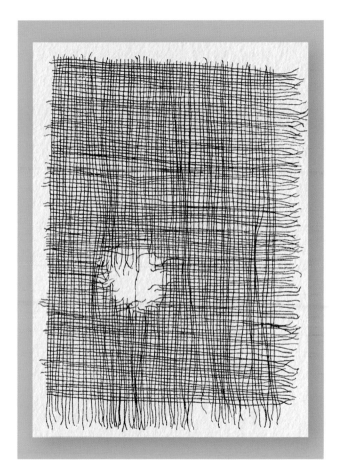

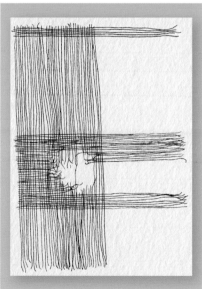

6 Then draw in the unbroken warp lines to the right of the hole, closing it off, and add some more weft lines above and below.

7 Finally, fill in the frayed weft strings to the right to finish the hole, then continue filling in the rest of the cloth with more warp and weft lines.

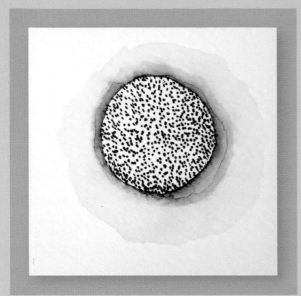

Dots (page 74) with bleeding ink circle.

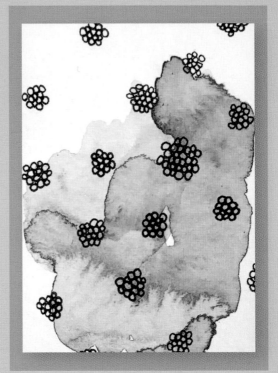

Circles clustered into pods over watercolor wash.

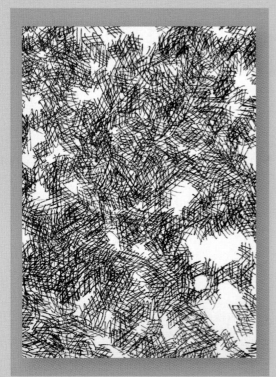

Heavily layered hash marks.

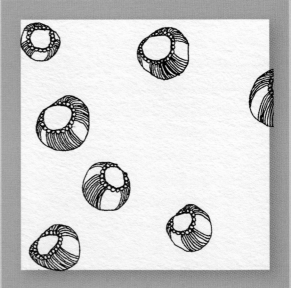

Round shapes with inner circles surrounded by tiny circles and curved lines.

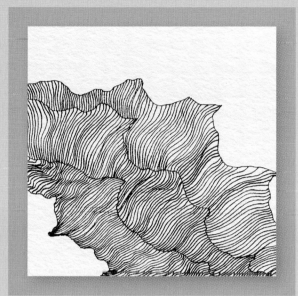

Edge (page 42) pattern variation.

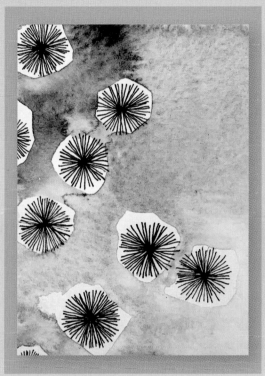

Exhale (page 58) variation surrounded by watercolor wash.

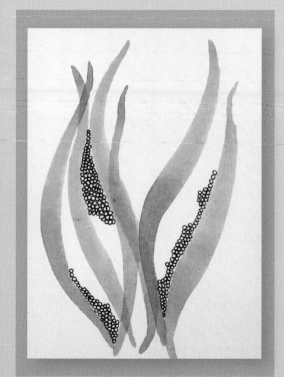

Gentle watercolor strokes and clustered circles.

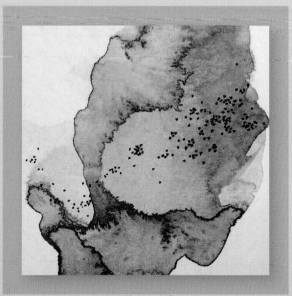

Watercolor wash with tiny Flock (page 104) marks.

# Room to Explore: Wander Pattern

The Wander pattern is based on kelp forests swaying in the waves and curious, wandering ivy. I've been drawing variations of this pattern for years, and it feels new again every time I tweak it. There's a lot of poetry in the way you can shape the leaves and twist and turn the stems. It's a pattern that embodies a lot of what I hope you take from slow drawing practice: a desire to wander, imagine and keep exploring. I invite you to draw Wander many times until you happen upon a few iterations that really light you up.

## Find the Poetry of a Line

When drawing the Wander pattern, what if you invoke the idea of finding the poetry of a line? I'm inviting you into a space beyond judgment where curiosity reigns, as you watch the line meander across the page. Give the line complete permission to do what it wants. You might even journal about this before or after drawing. What does "the poetry of a line" suggest to you?

For me, the poetry of a line is a loose, wandering, not-quite-so-neat approach to drawing. I'm not suggesting you draw carelessly. It's about letting go of making precise and neat lines for ones that move and wiggle in a way that creates movement and freedom. It's an approach that embraces the beauty of imperfection.

I find the poetry of a line myself by thinking of it as a modern dancer—arms aloft, billowing through space. To find this kind of poetry, I've also got to welcome awkward lines, unintended edges and drawings I might not like. To have space to make poetry, my line needs to have permission to make a mess.

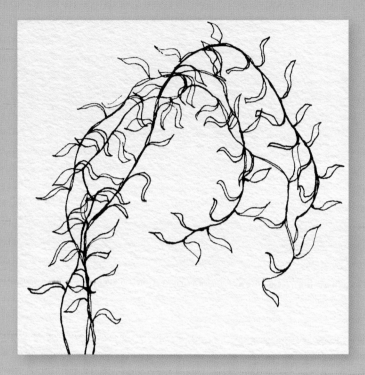

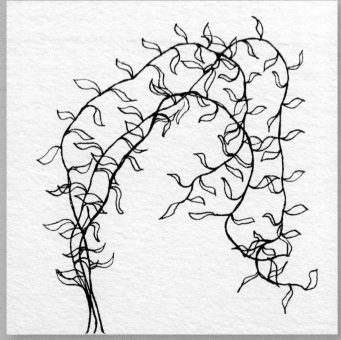

**1** Start your line in the bottom left of the page, allowing it to meander slowly upwards.

**2** To create a leaf as I've drawn it here, draw a line from the stem that arcs upward from the tip, moves down into a valley, then levels out. From the end point, echo the line above, with a small space in between, and return to the stem tip.

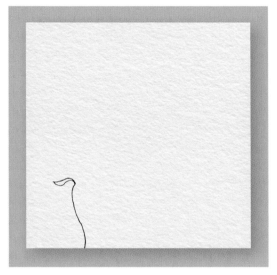

**3** Draw more leaves on the stem every so often, all on the left-hand side. Allow the leaves to be experimental and wonky, especially for first iterations of this pattern.

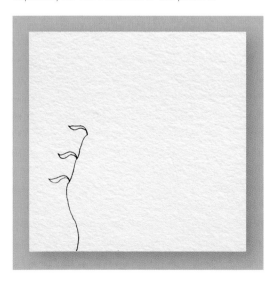

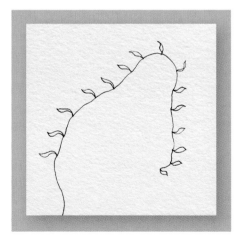

**4** Let the stem wander across the page, upward, sideways or downward. There is no right or wrong, just what pleases you.

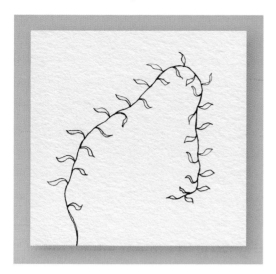

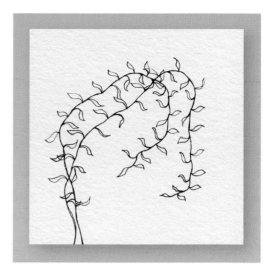

5 When you reach the point where you want the stem to finish, return to your **starting point on** the page. Go back over the stem and draw leaves on the right-hand side, in the spaces between the leaves on the left.

6 If you decide to add a second or third stem, start from the bottom left again and repeat the same process. Let one stem overlap another. This overlapping creates beautiful texture and negative shapes.

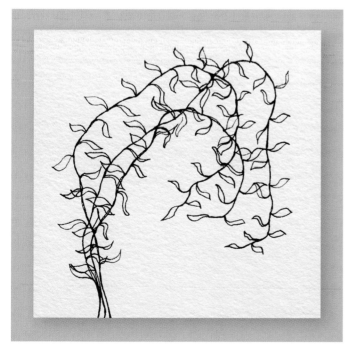

7 At the end, I like to stand back and look at the drawing with fresh eyes, and then I often create contrast by darkening some of the stems further. I also tweak where the ends of one or two of the stems reach.

If you wish to explore this drawing further, see pages 79 and 108 for creative variations.

# Creative Cues: What to Do with Your Slow Drawings

When you don't have an established art practice of your own yet, it can be hard to know what to do with all these creative little cards you've got piling up. One of the things I hear most often from beginner artists when they start slow drawing is: "These slow drawings are great! Now what should I do with them?" It's a good question and one that leads to making more art. I have so much fun incorporating my slow drawings into my art practice, and I'm excited to share some of the ideas here with you.

You may have some of your own ideas too, so grab some spare paper or a journal and jot down as many ideas as come to your mind, even if they seem weird or crazy—especially then.

By the way, I like to use an art journal for this exercise. In case you're not familiar with this, it's a visual journal—you can put anything in it: color swatches, collage, drawing, painting or text. I like to work on a watercolor journal as the pages are heavy and I can paint on them.

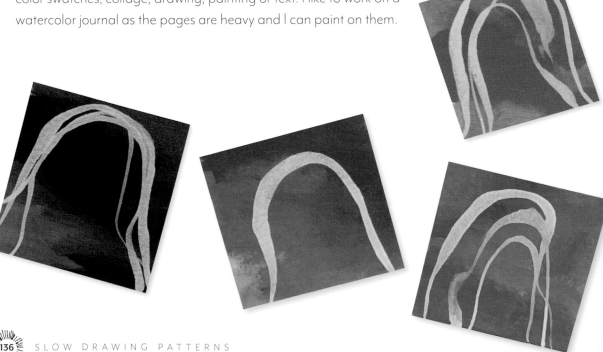

# Make a Collage Art Journal Page

Let's create a collage piece together. I'm working in an art journal. An art journal can be a recording of your creative musings, your day or just a space to be expressive. People make them in different ways, but for me, it's an anything-goes kind of space that is good for everything, from my creative brainstorms, to finished art pieces, to my grocery list. I can create in it as little or as much as I want, and I start and finish on any page I like. I love the permission and creative freedom I feel in the container of a book. To start, give yourself space to play and explore, as that's what will drive you to create more and in turn improve your art. You can work in an art journal like me or on a fresh sheet of watercolor paper.

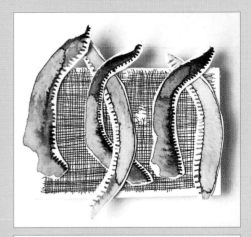

1. Begin by looking through your drawings. Pick several that catch your eye.
2. Gather your slow drawings, watercolor journal or paper, drawing pen, watercolor paint, paintbrush, scissors and glue (I like YES! paste or PVA glue).
3. Experiment with overlapping and placing drawings next to each other to get a sense of what looks good together. Be bold in your combinations.
4. You may wish to cut out some of your drawings or forms and tinker with arranging the elements in unexpected ways. Sometimes I pick them up and drop them on the table to see how they arrange themselves.
5. You can use the drawings as inspiration for a drawing or background on your page, or glue them down and then extend the drawing or painting onto the page, or glue the drawing down and that's it.

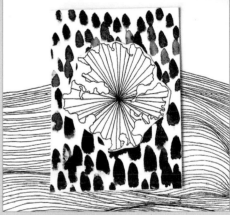

6. If you feel stumped about what comes next, try doing a lot more or less. For example, overlap your pieces more, put more pieces together or put just one element on the page. Try adding watercolor to the page or to the slow drawing, or paint black ink over the full page except for the slow drawing to make it stand out.
7. Finally, don't be afraid to approach your art journal pages minimally. The simplest things can be incredibly impactful and beautiful. Sometimes, I get to a certain point and the work feels done for now. That might mean I go back to it months or years later, or I might see it a few weeks later and decide it's finished. There's no right or wrong, but rather an open, patient process that allows the work to develop slowly. Have fun with it.

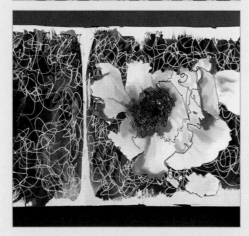

## Make a Handmade Card

One of my favorite ways to use slow drawings is to share a bit of delight through the mail. Slow drawing gives us a grounding, creative experience, so it's wonderful to bring some joy to someone else. I like to keep a stack of good-quality cardstock and envelopes in fun colors, so making a card is easy.

To make a slow drawing card, you can use the same process as with the art journal page, but perhaps keep it a bit more simplistic. I love making birthday and thank you cards this way, but my favorite is randomly mailing someone a little encouragement, even if you don't know them. During the first part of the lockdown in the pandemic—when things were really dark—I asked my students to send me the names and addresses of healthcare workers and folks in nursing homes, and I sent them slow drawing cards with words of encouragement, comfort or inspiration. Many of my students followed suit and continue this practice regularly. Given how rare it is to open up your mailbox and find a handwritten note, especially a handmade card, this is a very generous way to give to others.

1. Gather your cardstock, YES! paste or PVA glue, drawing pen and scissors.
2. Choose several different slow drawings that you might like to work with.
3. As with the previous exercise, begin arranging different pieces on the cardstock to see what pleases you.
4. Paste down one or more, leaving enough space for any text or drawing.
5. Use a drawing pen or gel pen to add text and details if you wish.
6. Extend your slow drawing to the envelope, using simple forms such as circles, dots, X-marks or lines in a cluster around the address to add a touch of playfulness to the envelope. Wouldn't it be fun to get some happy mail like this?

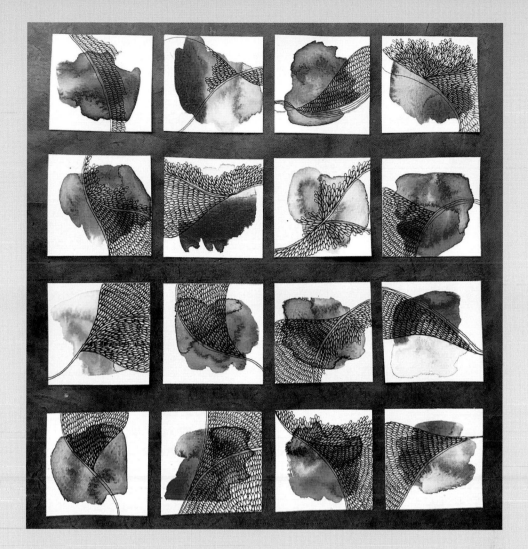

## Create BIG ART

Many of the patterns in this book lend themselves to building larger images from a set of small drawings. For the drawings above, I started with sets of four squares, then eight, and placed them together in different ways. I enjoyed watching the shapes change and bloom as I arranged the squares differently. Eventually, the piece grew to 16 squares, and I decided to experiment with watercolor to add a bit of interest. I would never set out to do this on a large sheet of paper—but working on small pieces was fun and playful, and I didn't want it to end.

**Paint or draw your patterns into the background of your art.** Many artists, such as Kehinde Wiley, use repetitive natural patterns as a background for their subjects. You can play with this idea, too. Here's some ideas for what to layer over your natural patterns:
· Draw a portrait of a person or an animal.
· Paste a photo or drawing of someone you love.
· Block letter a quote that is meaningful to you.
· Use a white gel pen or paint pen to write over the pattern, creating a textured, illegible surface.

# The Beauty of Imperfection

I'm going to address some of the issues folks often face when they first start slow drawing. For any of these issues, my best advice is to shift your gaze from judging to noticing. Disengage the inner critic from the job of making sure that you make "good art" or that you're not "wasting time and money," and get curious about what is appearing on the page, the way the ink dries and the sound of your breath. Curiosity is a powerful tool for grounding our bodies and our creative practice. A nonjudgmental stance helps you notice the beauty of imperfection in your drawings, and over time, you'll see how to use this to your advantage. It's a wonderful practice, both when I create and when I'm in nature.

## My hands shake and my lines are wobbly

The most common reason folks draw shaky lines is that they are going too fast. I know, it seems crazy to draw this slowly, but over time the practice can lead to more calm in your body and more accuracy in your drawings. I've practiced it so much now that when I pick up a pen and start slow drawing, my body immediately begins to calm down and my creativity is free to operate.

The second most common reason for shaky lines is shaky hands. In this case, I direct you to follow the example of artist Phil Hansen, who advises you to "embrace the shake." After developing a shake in his drawing hand, he decided that rather than fighting against it, he'd see what he could do with it. The modifications he's made because of this "dis-ability" have catapulted his career and creativity to new heights. When slow drawing, if you embrace the movement of your line, your shaky lines will have a consistent texture and line quality, such that you bring a new feel to each pattern which is consistent unto itself. The more you dig into drawing the pattern your way, the more

you'll find your beautiful iterations of it. You may want to take more inspiration from Phil by exploring different materials or working larger with the patterns as well if that feels fun. I highly recommend checking out his TED talk, his work and more here: https://www.philinthecircle.com/.

## I can't slow down

This is another really common problem in the beginning. Since we're so used to focusing on productivity and rushing about everywhere, slowing down can feel unfamiliar and uncomfortable at first. Your body may resist and tense up in response. It's okay to approach slow drawing as a process. Maybe you need to experiment with starting less slowly, and then see if you can slow down gradually. You can also experiment with drawing more slowly than you think is necessary, and keep playing with this until you get smoother lines. Be patient with yourself.

Your art practice can be a place for you to come and land. A place where you don't have to perform—you can just explore and be. Now that I'm so familiar with the process, the slower I draw, the more relaxing it feels and the more accurate my lines. I find cultivating a mindful practice really

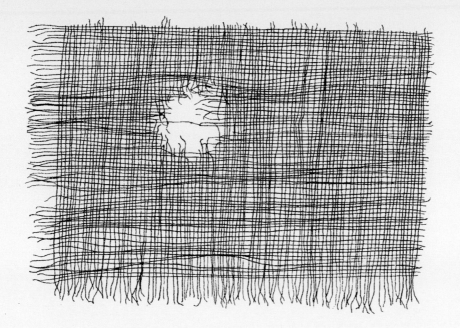

helped me to find that sanctuary space in my art; I hope it does for you, too.

## My hand is sore

It's very common in the beginning to find yourself holding a death grip on the pen. As in meditation, when you notice this, just acknowledge it and play with different ways of holding the pen or brush to see what feels good to your hand. Using your nondominant hand is another fun way to trick yourself into letting go, especially with brushwork.

## Mine don't look like yours

Overall, I would say that it's a good thing that yours don't look like mine. But if what you mean is that you are struggling to master the skill used in the pattern, then I understand your frustration. What I always tell students is that there is a dance we do between developing artistic skill and developing the skill of drawing mindfully and slowly. The beautiful thing is, as your ability to draw mindfully improves, so too does your artistic skill, as mindful drawing helps us let go of our inner critic, making way for repeated practice and noticing the ideas that bubble up in the imagination so you can make your unique art.

## I'm having a hard time with this pattern, and I guess I stink at art

Keep your focus on the process of making art, more than the product. I know it sounds strange, but the more you focus on what it feels like to create in a mindful way, the more you let go of the pressure to perform and the more space you have to both relax and improve your art skills. I also find that mindful art creates a lot of space for my artistic voice, because it's not being drowned out by my inner critic. This is a beautiful, low-pressure practice you are creating for yourself. Trust your own voice and dive in. Your patterns may look very different from mine, and that's a good thing. We already know what Amy would do with these patterns—let's see what you might do.

# Index

# Acknowledgments

I would like to thank my husband, Pete, for being an incredible support—his partnership in both life and creative endeavors allows me to keep reaching higher.

I'd like to thank the amazing team at Quarto, especially Anna Galkina, Kate Kirby and Caroline West for their support, openness and gentle edits. I want to also thank Martina Calvio for her design vision. She wove together my aspirations for a book that felt colorful and creative while also grounded in nature. I think the result conveys the deeply imaginative, calming and mindful practice of slow drawing patterns from the natural world. I hope you agree.

I'd like to thank the members of the Mindful Art Studio community. Since the beginning of the pandemic, slow drawing together online has been a way to connect to one another and our creativity in a time of disconnection and discontent. Their continued investment in a weekly slow drawing practice is one of the factors that pushes me to keep my own practice alive and fresh. Their responses have helped me to see which patterns hit that secret recipe: a combination of simplicity and malleability.

I feel very blessed to do this work—to help people find their creative spark, foundation and path. Thank you for that opportunity.

# Resources

## Recommended Reading

*Braiding Sweetgrass: Indigenous Wisdom, Scientific Knowledge, and the Teachings of Plants* by Robin Wall Kimmerer
*A Creative Companion: How to Free Your Creative Spirit* by Sark
*The Creative Habit: Learn It and Use It for Life* by Twyla Tharp
*The Curious Nature Guide: Explore the Natural Wonders All Around You* by Clare Walker Leslie
*The Mandala Book: Patterns of the Universe* by Lori Bailey Cunningham
*An Ocean Garden: The Secret Life of Seaweed* by Josie Iselin
*Steal Like an Artist: 10 Things Nobody Told You About Being Creative* by Austin Kleon

## Online Resources

- Embrace the Shake: TED Talk by Phil Hansen
  https://www.ted.com/talks/phil_hansen_embrace_the_shake?language=en
- Kehinde Wiley
  https://kehindewiley.com/